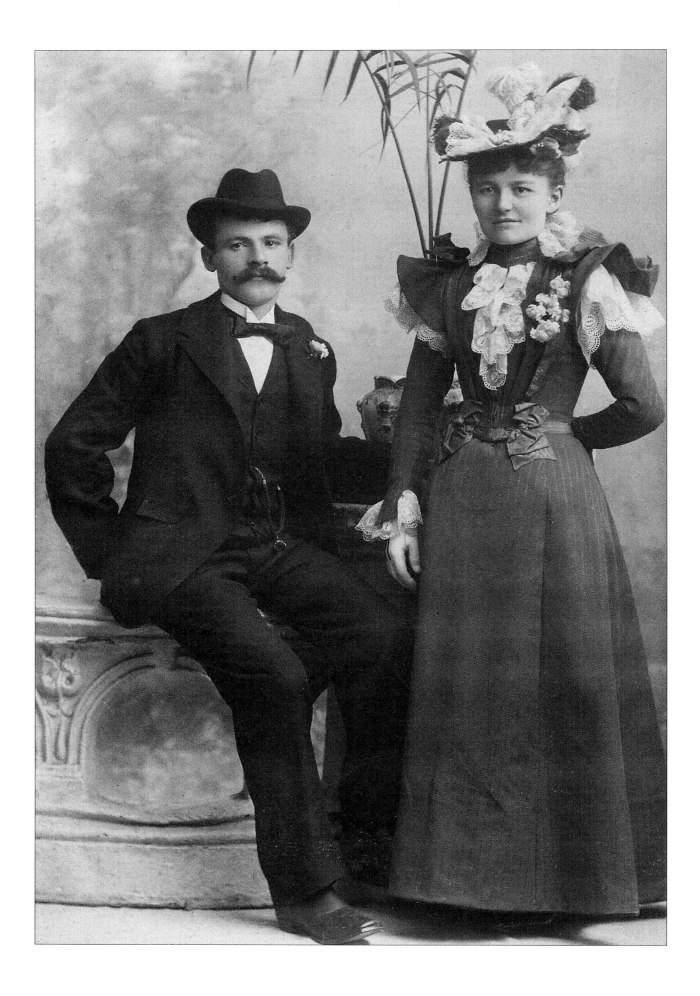

Victorian Fashion
in America
264 Vintage Photographs

Edited by Kristina Harris

Dover Publications, Inc.
Mineola, New York

FRONTISPIECE: c.1899. The gentleman wears a typical suit trimmed only with a watch fob and flower, along with boots and a felt hat. The lady wears a winged and plumed hat and a dress trimmed with lace, eyelets, flowers, and ribbons. (*"Hyland, Washington St., Cor. Seventh, Portland, Ore." Cabinet card.*)

Bibliographical Note

Victorian Fashion in America: 264 Vintage Photographs is a new work, first published by Dover Publications, Inc., in 2002.

DOVER *Pictorial Archive* SERIES

Library of Congress Cataloging-in-Publication Data

Harris, Kristina.
　　Victorian fashion in America: 264 vintage photographs, 1855–1910 / Kristina Harris.
　　　　p. cm.
　　ISBN 0-486-41814-6 (pbk.)
　　　1. Costume—United States—History—19th century—Pictorial works. 2. Photographs—Dating. I. Title.
GT610 H37 2001
391'.0022'2—dc21

2001047520

Book design by Carol Belanger Grafton

Manufactured in the United States of America
Dover Publications, Inc., 31 East 2nd Street, Mineola, N.Y. 11501

Introduction

Photographs are time machines—giving us a fascinating glimpse into everyday life in the past. They are important documents in the study of fashion, second only to existing garments. (In many ways, photos are superior to existing garments, because they show us *exactly* how garments were worn.)

Though fashion drawings may display tightly corseted waists, flat bellies, and enormous bustles, photographs show the reality of fashion, which may reveal that tight corsets were not the norm, that women's bellies bulged, that bustles or hoops were worn smaller than fashion plates would have us believe, and that gloves or hats were not always mandatory. Photos also tell us what a woman's posture was like in a hoop-skirt, what was considered a "manly" or "ladylike" pose, how hats were tilted, and many other details that couldn't be accurately discovered in any other way.

Too, photos expose the gulf between what the wealthy wore and what the poor wore. This is especially poignant when it's considered that, just as they do today, people always tried to look their best when sitting for a portrait. This tendency was perhaps even stronger in the nineteenth century, when family photos were frequently displayed in parlors for guests.

Photographs are also collectible and important historical documents in their own right. At nearly every antique store or show, boxes can be found stuffed with sepia images of the past. Some people collect only "rare" images (of children with toys, for example), but a great many people buy old photos simply because they like the look of these people whose relatives seem to have forgotten them. (A running joke among dealers is to label boxes of old photos "Instant Relatives.")

Dating the Images

There are two ways of determining a date for an image: examining the type of photograph and examining the fashions illustrated in the photo. Both methods were used in this book; for maximum accuracy, both should always be used.

I began collecting photographs because of the fashions depicted in them; therefore I often begin my journey into dating an image by studying the clothing shown. For photograph collectors, adding fashions to their repertoire can greatly help them pinpoint the dates of images. This method of dating, if used by itself, does, however, have its limitations.

Though fashion historians know when a style first appeared or first became popular (not necessarily the same), we can't say for certain when a given person might have begun wearing it. Was it a month after it was first touted by the major fashion magazines, or more than a year later? When did the style come to an end? Did everyone suddenly stop wearing the style all at once, or (as is more likely) did its popularity wane gradually?

For the most part, since following fashion was far more socially important in the nineteenth and early twentieth centuries, it can be assumed that a person in a portrait photo was at least trying to keep up with the latest styles. (As author Priscilla Harris Dalrymple asks, "Why else would a lady strike a full-length profile pose in a dress with a bustle?") Still, there were always individuals who clung to out-of-date fashions.

Another problem with this dating method is the way historians determine the coming and going of styles: primarily through fashion magazines. Until about the teens of the twentieth century, fashion magazines offered mostly drawings, which are always idealized. Even fashion magazines that published photographs can be misleading. Just as do contemporary fashion magazines, they showed idealized or extreme fashions rarely seen in everyday life. Trying to date clothes worn by real people in studio photographs by comparing them with fashion illustrations can therefore lead to difficulties.

Nonetheless, by comparing the shape of a hat, a sleeve, or a skirt with what fashion magazines described and pictured, a rough date may be determined: a date when the fashion first became popular and the last date when most people considered it fashionable. This is easiest to do if there are women in the photograph, since, in general, women's fashions changed more rapidly than children's or men's, and tended to be more slavishly followed.

Sometimes old photos carry handwritten notes stating who the pictured person is, along with an apparent date. Such dates have frequently been added long after the photos were taken and are not necessarily accurate. They should never be used alone to date photos or fashions, though it's reasonable to take them into consideration if they fall within the period determined by other methods.

Which brings us to the second method of dating old photos: the photos themselves. Always consider what type of photograph you have (tintype, cabinet card, etc.) when trying to date an image. This is easier than it sounds and can provide

some very helpful data (although care must also be taken here, since photographers sometimes used out-of-date methods or old card stock). Whole books have been written about the various types of photographs, and I encourage you to study them—but here are some basics.

Types of Photographs

Daguerreotypes (pronounced dah–*gehr*–o–types) were introduced in 1839 and were last popular c.1865. Some people still make daguerreotypes today, but generally speaking, their most popular period for portrait photography was c.1852–54, and they died out by the 1860s. Essentially, a daguerreotype is a photo made on a silver-coated copper plate. The first American daguerreotypes were made just six months after the details of the technique were published in 1840. By the mid-1840s, almost every major American city had a daguerreotype studio, and it's estimated that between 1840 and 1860, thirty million daguerreotypes were made in the United States, each client paying between $2 and $5 per pose. (For many people, this was more than a week's pay.)

Daguerreotypes have a shiny, mirror-like metallic surface, and when you tilt a daguerreotype to a certain angle, it looks ghostlike—what seemed dark is now whitish. One way to differentiate between a daguerreotype and other types of photos is to stand the image upright on a table and place a sheet of white paper flat on the table in front of it. If the image suddenly appears to be a negative, it's a daguerreotype. The face of a daguerreotype should never be touched, since this can ruin its special properties.

Some daguerreotypes were delicately hand-colored, but most were not. Daguerreotypes were originally placed under glass and set inside decorative cases for protection; most are still found in their original cases.

Calotypes (sometimes called Talbotypes, after their inventor William Henry Fox Talbot) were the first photographs on paper. Introduced in 1841, they were most popular c.1852–54, and were last made in 1862. Calotypes are fairly rare in America, due to original patent restrictions. Calotypes are often very faded and pale yellow today.

Ambrotypes are images on glass plates; they were first made in 1854 and last made in 1865; their most popular years were c.1857–60. By 1865, ambrotypes were available in nearly all American studios, as a less expensive alternative to daguerreotypes. In fact, by about 1856 ambrotypes were more widely used than daguerreotypes. Unlike daguerreotypes, ambrotypes don't have a wide range of contrast; highlights aren't white, and dark areas don't have much detail. It's more typical for ambrotypes to be hand-tinted, although ambrotypes without tinting were about half the price of daguerreotypes.

Tintypes, which are images on iron plates, are the better known cousins of the ambrotype. Sometimes also called ferrotypes, ferrographs (*ferro* is Latin for "iron"), or melainotypes

(*melaino* is Greek for "black"), tintypes were first seen in 1854, and their popularity essentially ended by 1867; however, from the 1890s to the 1930s tintypes were often taken at carnivals and fairs, and they are still made today in some specialty studios. From roughly 1870 to 1885, tintypes were also made with brown japanned metal, giving them what photographers called a "chocolate" tint. In all cases, however, whites are never really white in tintypes, but typically gray.

Being far less fragile, tintypes soon superseded ambrotypes. Because tintypes were inexpensive (10 to 25 cents for untinted versions), a great many men heading into battle during the Civil War had them made of themselves or their loved ones. They were easily cut into special shapes to fit into brooches, pins, and other jewelry. The tintype was never as popular overseas, where it was known as the "American process."

Tintypes tend to turn dark as they fade, since they have a base of black. They also frequently develop a "halo" effect, in which a circle of gray and black develops around the edges.

Both ambrotypes and tintypes were placed under glass and in cases, like daguerreotypes, but they were also placed in paper sleeves. (Tintypes often have clipped edges, making them easier to slip into albums.) It's more common to see ambrotypes and tintypes without cases than it is to see daguerreotypes without cases. To determine whether an image is a tintype, use a small magnet; a true tintype will be attracted to it.

Albumen prints were made from glass negatives and printed onto paper coated with egg white. (It's estimated that six million eggs were used in 1866 alone for this process.) Introduced in 1850 and last made around 1910, they were most popular from 1860 to 1890. Unlike calotypes, albumen prints have a semigloss surface. Albumen prints include the subcategories of cartes de visite, cabinet cards, and stereo cards. They were originally placed in paper sleeves and glued to cardboard mounts.

Cartes de visite (French for "visiting cards"; pronounced cart–duh–viz–*eet*, and popularly known as CDVs), first appeared in 1854. These diminutive photos got their name from their calling card-sized mounts. They are albumen prints measuring about 2½ x 3½", mounted onto cardboards measuring approximately 2½ x 4"; they were most popular c.1859–66, and were not made after the 1910s.

CDVs didn't become popular in America until c.1858. By 1860, more of them were produced than any other type of photo. Usually, CDVs were placed in paper sleeves or inside photo albums. By the 1870s, CDVs were mass-produced for public consumption, with images of actresses and other famous people. The CDV was called "the poor man's portrait," and was even used for criminals' mug shots.

From c.1858 to 1869, CDVs were glued to thin cardboard rectangles whose thickness was about .01–.02". From c.1861 to 1869, borders of one or two lines were often used on the boards. In c.1869 and 1870, the card's thickness was generally .020". After about 1863, the images, though not the cards they were mounted on, might be oval-shaped. (Oval frames with

tassels can be dated to c.1864–67.) After c.1871, the card's corners were rounded. By 1873, the card was occasionally colored. After about 1875, its edges might be beveled. By 1880, the card was at its heaviest, and deep shades of reddish brown, hunter green, or maroon were often used; the back often had an elaborate ad for the photographer. By the 1890s, the edges might be scalloped.

Cabinet cards are albumen prints measuring about 4 x 5½", glued to cardboard mounts usually measuring about 4½ x 6½". These were introduced in 1863, were adopted by American studios by 1866, and were popular from around 1870 to 1900. They were last made in the 1920s. By World War I, these images were produced on gelatin-silver paper rather than albumen paper.

The first cabinet card backings were light cardboard in soft shades, generally gray and brown. By 1880, the images were glued onto many colors of cardboard, and below the image the photographer's imprint was often placed. From around 1885 to 1892, the card might have beveled edges, sometimes trimmed with gold. In the 1880s, deep wine-colored cardboard was popular, while during the 1890s, notched edges and fancy photographer ads on the back were common. From c.1866 to 1880, the cardboard often featured red or gold rules in single or double lines; c.1884–85, wide gold borders were popular. From about 1880 to 1890, scalloped borders were frequently used; c. 1889–96, single-line rules with rounded corners were fashionable; c.1866–80, red or gold rules in single or double lines are often found. After 1900, cabinet cards generally had much more cardboard surrounding the photo, and could be quite large.

Stereo cards were used with stereoscopes—hand-held viewing glasses that gave an illusion of depth. Introduced in America in 1854 and, for the most part, not produced after 1925, they were widely popular from around 1858 to 1905. Alternative names for stereo cards include stereographs, stereoviews, stereoscopic views, and stereotypes.

These images were commercially produced for entertainment value, not for family portraits. Photographer O. Henry Mace called stereo cards "Victorian television." Images of places are most often found, but miniature "stories" that included people were also popular. Very early stereo cards were made on glass or metal, but usually stereo cards are found glued to cardboard, measuring about 3 x 7". Before the 1890s, they were colored by hand; afterwards, they were printed in color. If a card has squared corners and measures about 3½ x 7", it dates from before 1869. By 1873 the card was enlarged to 7 x 4–4½", a size that stayed popular until c.1885. As with CDVs and cabinet cards, the first cardboard mounts were light in weight. The cardboard was usually a shade of white, or sometimes gray. In the 1860s, the cardboard got heavier and the corners were rounded. In the 1870s and 1880s, mounts could be a variety of colors, even bright orange or yellow; later they reverted to their original white or gray. Because they were handled a great deal, they tend to be in poorer condition than many other types of albumen prints.

Gelatin prints were images on gelatin-coated paper. The gelatin print was first produced in 1871 and was the form of photography that caught on with amateur photographers—including George Eastman, creator of the Kodak company. This type of photo is usually silvered to some extent (it looks silvery when held at an angle). A modernized version of gelatin prints is still in use today.

This list represents the common types of photos found in the United States, but it is by no means complete. Many other sorts of old photographs can be found—you may even find some on odd materials such as fabric or leather.

But whatever type of photograph you find, I encourage you to preserve and study it—you never know how much history you may discover!

The Fashions

Fashion is often called frivolous—or at best artistic—and while it can sometimes be both, the clothes we wear are also a mighty stack of evidence about who we are, both as individuals and as a society

One article of clothing that illustrates this perfectly is the woman's hat. In the early 1800s, American women wore bonnets that hid the face like blinders. After the 1850s, however, women wore small, jaunty hats that highlighted their faces. Women were emerging from their cocoons—even rollicking to the polka and brazenly dancing the waltz (which once shocked good citizens because of its "immodesty").

During the Civil War, women's clothing often made silent political statements, incorporating military-style bands, stripes, stars, and epaulets. Women's fashions also reflected increasing personal liberty; hoops replaced many layers of starched petticoats, making clothes considerably lighter. Women became more active; sports were now considered acceptable for ladies.

Backward strides were taken in the late 1870s and early 80s, with the popularity of the uncomfortable and restraining "mermaid" style of dress, which clung to the figure and ended in a long train. During this period, Victorian women often complained that their skirts were so snug, they had to give up their favorite sports.

However, the 1870s and 80s were also a time of dress reform. No longer did serious reformers prescribe things like Bloomer outfits (which were modeled upon Turkish trousers); such clothing was so foreign to Americans, it provoked only laughter. The new reformers made modest modifications that wouldn't assault current taste. Corsets were loosened, petticoats were reduced, and trains banished. The changes were gradual—but effective. The standard fashions of the 1890s could be traced directly back to reform costumes of the 1870s and 80s.

"The New Woman" was what the modern female of the 1890s was called. It wasn't uncommon for her to have some sort of work outside the home, if only for the sake of getting out of the house; to women who had to work to support them-

selves, there were more fields open than ever. Women's clubs formed all over the country, and whether the cause was temperance, the vote, or the general idea of improving women's and children's lives, American women were now more active than ever before—and their clothing reflected this. Participation by women in sports was at an all-time high, and for the first time, women could appear in public wearing pants without too much ridicule, by riding or pushing a bike.

For everyday wear, most women chose from one of two styles: the tailored dress, which mimicked men's suits, or more frilly dresses, often in a shade of white. The latter style, which developed into ever more frothy, sheer dresses as the century ended, would later be dubbed the "lingerie dress" because it resembled dainty underwear. Women were living in two worlds: one the "ultrafeminine" domestic sphere, and the other, the once strictly masculine realm of workplace and politics.

In the early 1900s, women's suits were standard wear by day, with dresses trimmed with lace and beads by night; women moved between two apparently separate worlds. A considerable number of American suffragettes made a point of wearing the latest in elegant, frilled dresses whenever possible, to demonstrate that they were not all Amazons. This may well account for the sharp inclination toward ultrafeminine dresses during the early 1900s.

Men's Victorian fashions were also transitional. Compare the extravagant men's suits of the eighteenth century with those pictured in this book, and you'll have a good idea of how radical the changes were. In the early 1800s, the idea grew that men should appear to take little interest in how they dressed, and—most importantly—that they should always be inconspicuous. By the 1860s, the basic structure of men's dress from that time forward was set: a plain suit, a plain shirt, a tie, and a plain hat.

The Victorian era also saw dress reform for children. Before the nineteenth century, children's clothes were miniatures of their parents'. Girls wore corsets and large panniers, and boys wore miniature suits, complete with vest, tight pants, cravat, and fussy jacket. Beginning in the early 1800s, however, many parents felt that clothing ought to be comfortable enough to play in and shouldn't be detrimental to their children's health. Amazingly, these were radical ideas at the time.

Attempts at reform were not always successful, however. Starting in the late 1880s, for example, little boys all over the country were mercilessly fastened into frilly velvet suits inspired by the novel *Little Lord Fauntleroy*. For little girls, styles imitating Kate Greenaway's illustrations were sometimes favored: low necks, thin fabrics, and long trailing skirts.

Young siblings in the Victorian era often dressed identically. This didn't provoke embarassment, as it probably would today. Even teenage sisters would wear dresses of the same cloth sewn into the same design as those of their baby sisters. For Victorians, family was all-important, and this was just one way they expressed that sentiment.

So, whether you're studying a small boy wearing a loose-fitting dress, eyeing a gentleman in his work suit, or contemplating a "New Woman" in a lingerie dress, I urge you to stop a moment and consider what these costumes might reveal about the individuals who carefully chose them to be photographed in. It might just bring you a step closer to understanding our ancestors.

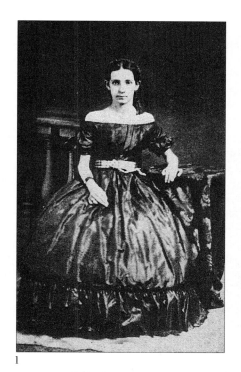

1

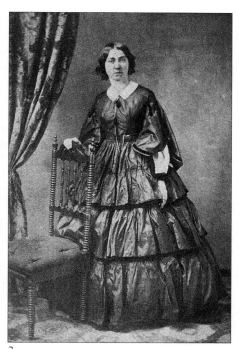

2

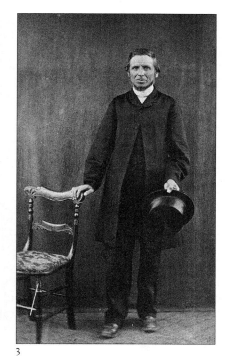

3

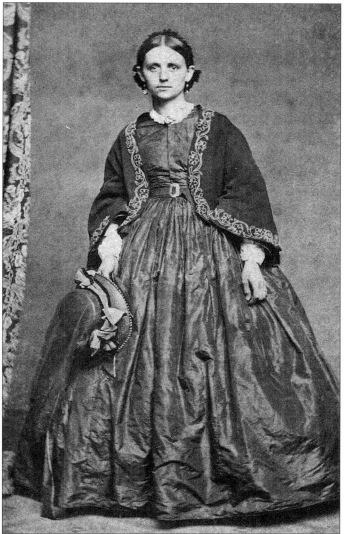

4

1. c.1855. A lady in a fashionable gown with dropped shoulders. (*CDV.*)

2. c.1855–58. The sleeve design and tiered dress on this woman's skirt were at the height of fashion at this time. (*CDV.*)

3. c.1856–58. Signed "For Mrs. I. Gallup," this photo shows a man in typical everyday attire. (*CDV.*)

4. c.1860–62. "Mrs. Sarah J. Hatch," quite a fashionable lady, carrying her new-style hat (not a bonnet, which she would have worn a few years before). Her skirt is quite full and has a rounded waist, and she wears a "paletot" jacket with pagoda sleeves. Notice her dangle earrings. (*CDV.*)

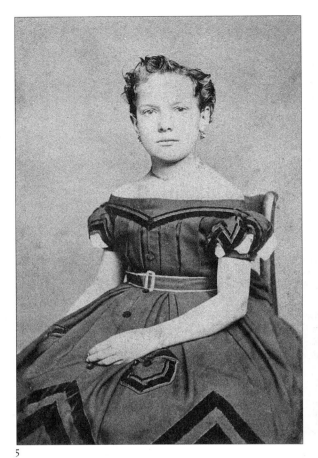

5

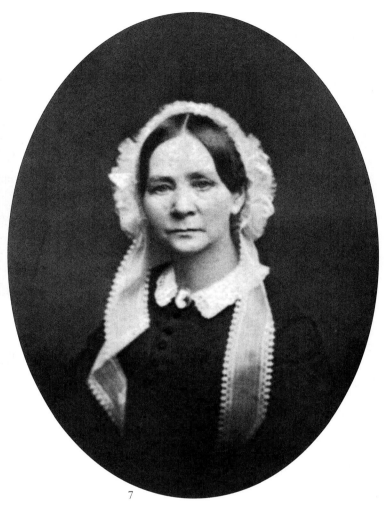

7

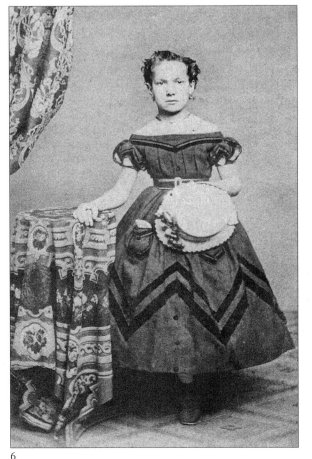

6

5 & 6. c.1861. By the 1860s, off-the-shoulder dresses were considered unhealthy and vain for children, but this girl's full skirt is definitely from the '60s. Her dress shows much attention to detail: notice the intricate puff sleeves, the pleating on the bodice, the trimmed pockets, and the general harmony of design. (*CDV*.)

7. c.1861–65. This woman wears a typical indoor headdress for married ladies. ("*Manchester, Bro. & Angell. 73 Westminster St., Prov. R.I.*" *CDV*.)

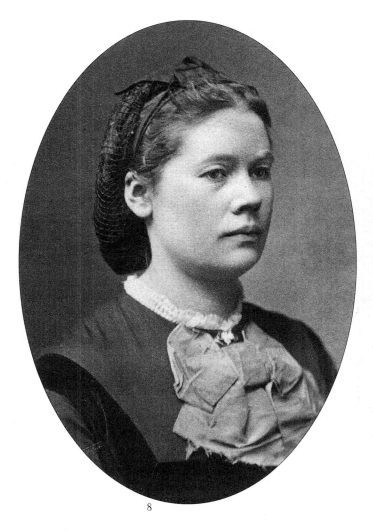

8

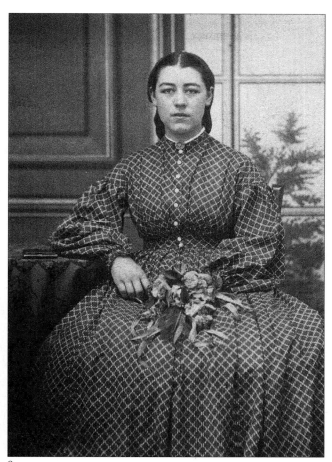

9

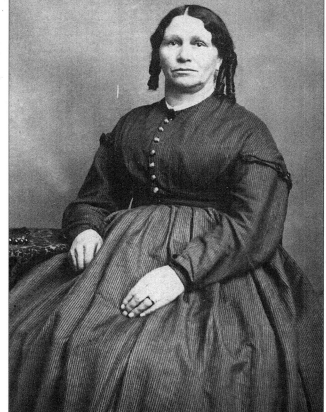

10

8. c.1861–66. A woman wearing a snood (a decorative hairnet) in her hair. ("*Adolph Westphal's Photographic Gallery, 148 West Randolph Street, Chicago.*" CDV.)

9. c.1861–66. A typical young lady of the era, wearing a fashionable but very modest dress. ("*Mrs. J. A. Reed, Photographist, Morris, Ill.*" CDV.)

10. c.1861–66. Though this woman's dress is modest, it does follow the correct lines of the era. ("*Joseph Even, Photographer, Morris, Ill.*" CDV.)

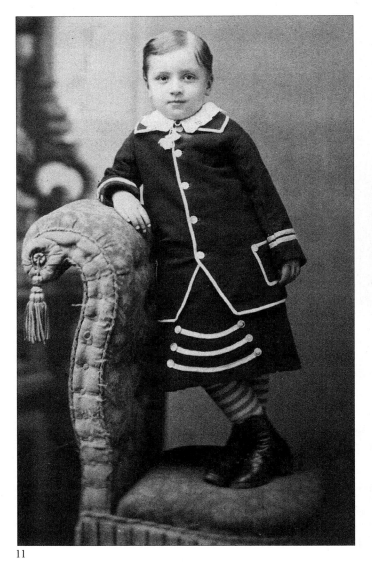

11

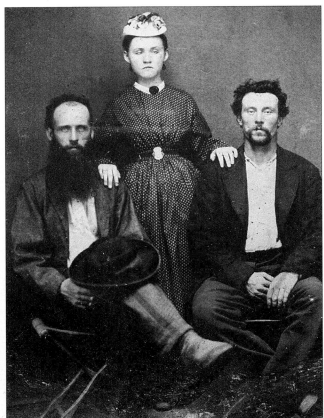

12

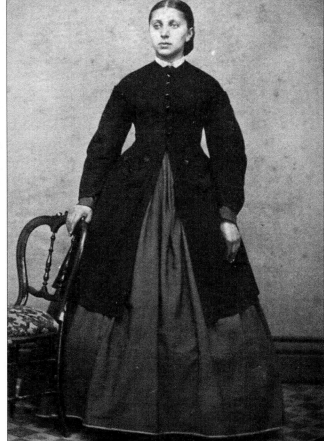

11. c.1860s. This little boy is very fashionably dressed in striped stockings and a slim-cut dress trimmed with white braid. ("*San Francisco Gallery, (Buchtel's Old Stand,) W. N. Towne, Artist, Cor. First & Morrison Sts., Portland, Ogn.*" Cabinet card.)

12. c.1860s. The woman wears a simple dress and hat of the period; the men wear the clothes of working men. (*Tintype.*)

13. c.1861–65. "Aunt Fanny Sims" in the simple attire many American women were forced to adopt during the Civil War. Her unadorned dress and overjacket indicate she was of little means. (*CDV.*)

13

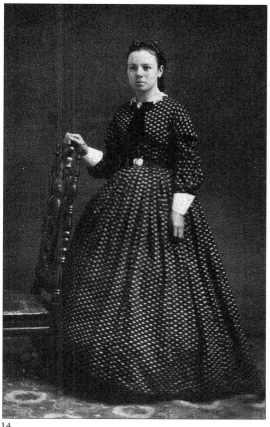

14

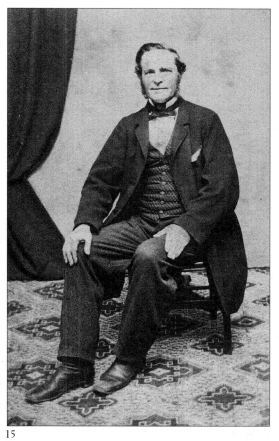

15

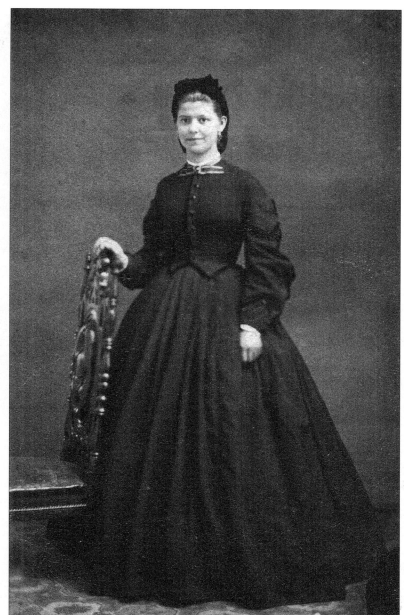

16

14. c.1861–66. This simply dressed young woman's hoops appear to have been thrown forward by the photographer's headrest stand. (*"Rankin & Co.'s. Cartes de Visite Rooms, 231 & 233 Central Avenue, Cincinnati."* CDV.)

15. c.1861–66. A man with well-worn shoes and a printed vest. (CDV.)

16. c.1861–66. A young woman with a rare hint of a smile. Her dress is very simple, but follows fashionable lines. In her hair she wears a snood. (*"Rankin & Co.'s. Cartes de Visite Rooms, 231 & 233 Central Avenue, Cincinnati."* CDV.)

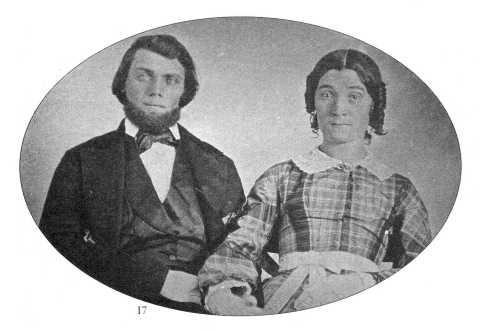

17

18

19

17. c.1863–64. In this photograph taken about the time cabinet cards first appeared, a couple wears conservative, almost old-fashioned clothing. (*Cabinet card.*)

18. c.1864. "Mrs Davis" in a white flounced evening dress with a wide scooping neckline and an overskirt. Her sleeves feature unusually wide flounces of lace. (*CDV.*)

19. c.1864. Note the sleeves on this woman's dress, with all the interest at the elbows. She also appears to have a Civil War-related belt buckle. The photograph was taken in Canada. While Canadians certainly took interest in (and some even fought in) the Civil War, this woman may be a temporarily transplanted American. ("*D. Campbell, Photographer, Goderich, CW.*" *CDV.*)

20. c.1864–65. Although this woman's hairstyle is indicative of an earlier era, her dress, with its relatively slim sleeves, high neckline, and full skirt, is very much in style. This is a c.1920s–30s copy of an authentic daguerreotype. (*Gelatin print.*)

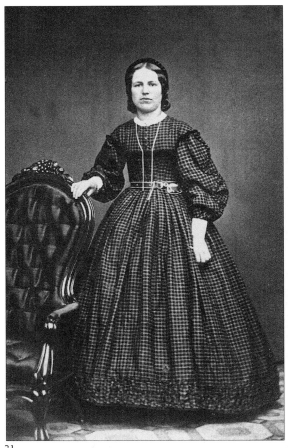

21

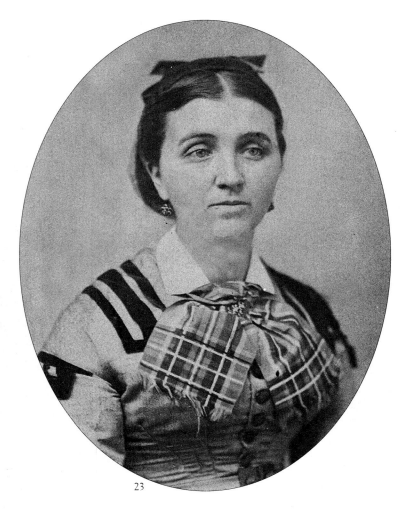

23

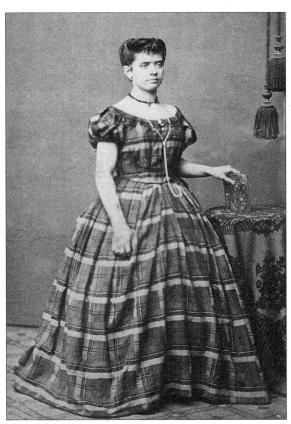

22

21. c.1864–65. A simply, but well-dressed, woman. Notice her full sleeves that fit only at the wrist. (*"From E. L. Johnson's Photograph Gallery, Goderich, C.W." CDV.*)

22. c.1864–65. This woman's dress is oddly ill-fitting. It appears to have a fullness in front; the hem is too short in front, and she wears no corset—all of which suggests pregnancy. The ever-so-slightly pointed waistline is typical of 1864, and the plaid fabric was popular throughout the 1860s. (*"Photographisches Institut von Gustav Hager, St. Paul, in Carl Schultzes Theater im Garten." CDV.*)

23. c.1866–69. A fashionable woman whose dress is embellished with then-popular plaid and military-inspired trim. (*"T. T. Tuthill, Moravia, N.Y." Cabinet card.*)

24. c.1864–66. This little girl's plaid dress trimmed with ribbon in a geometric design is quite typical. Notice the photographer's stand behind her. (*"G. Schneider, Photographer, Gallery Room, 110 North Clark Street, Chicago Ill." CDV.*)

25. c.1864–65. A young woman attempting to be fashionable in a geometric-trimmed skirt and fashionably shaped bodice. (*"Rankin & Co's. Cartes de Visite Rooms, 231 & 233 centr'l avenue, Cincinnati, O." CDV.*)

26. c.1866–68. Notice this woman's tiny bonnet and full shawl. (*"H.M. Phelps, Morgan, Ohio." CDV.*)

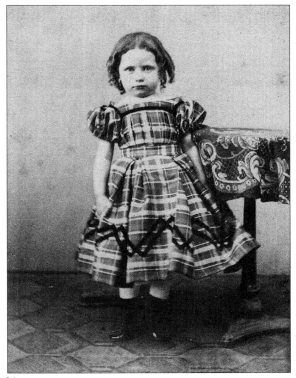

24

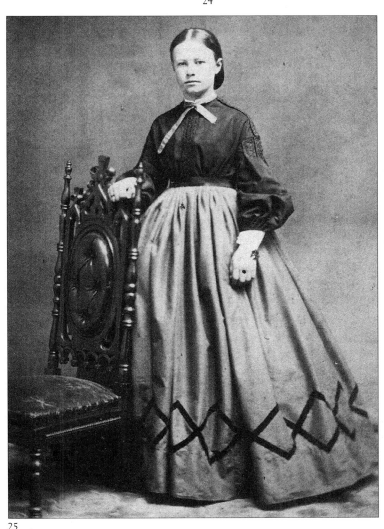

25

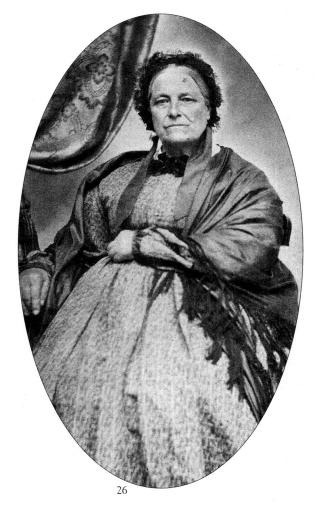

26

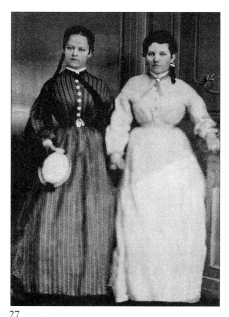

27

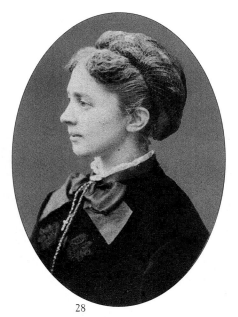

28

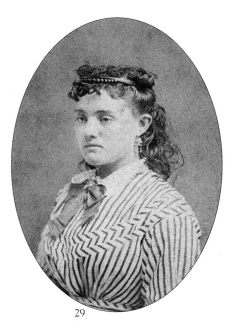

29

30

27. c.1865–69. These two young ladies wear modestly wide skirts with full lower sleeves. The woman on the left carries a fashionable hat. Their skirts would have been considered short; notice how the photographer has wiped out their feet because of this, so that they appear to be floating. Some Victorian photographers made a practice of this, thinking it unseemly to allow a lady's feet to show. (*Tintype.*)

28. c.1865–70. This woman wears a fashionable snood with her velvet outfit. (*"Taylor & Brown, 912–914 Chestnut Street, Philadelphia." CDV.*)

29. c.1868. Victorians were clever with their stripes, as this young woman's dress illustrates. (*"Hoag & Co. Photographers, 100 W. Fourth Street, Cincinnati, O." CDV.*)

30. c.1867–68. A woman wearing a dress from the period of transition between the hoop and the bustle. (*"Spurr, Preston, Iowa." CDV.*)

31

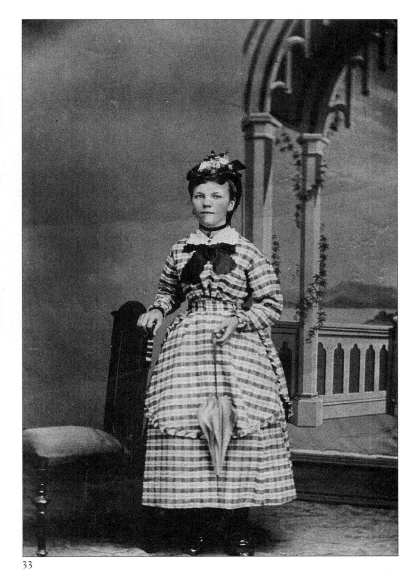

33

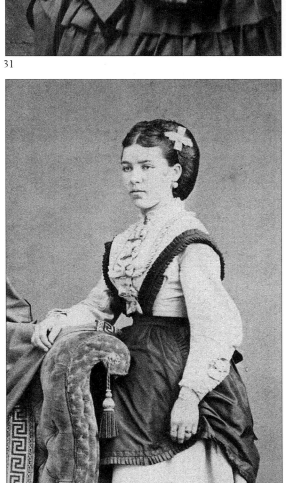

32

31. c.1867–68. This woman wears a long bodice and holds a matching fur-trimmed hat. ("*A. Dolph, Photographer, Rock Creek, Ohio.*" *CDV.*)

32. c.1868–69. As the bustle took its hold on fashion, overskirts (frequently separate jumpers, as shown here) were born. Notice the snood in this woman's hair, and her jewelry. ("*From J. H. Heering's First Premium Photograph Studio, First Street, San Jose.*" *CDV.*)

33. c.1869–70. This young lady is about 15, judging from the length of her skirt, but is highly fashionable in a checked transitional dress (between hoops and bustle), with a smart hat and a parasol. (*Tintype.*)

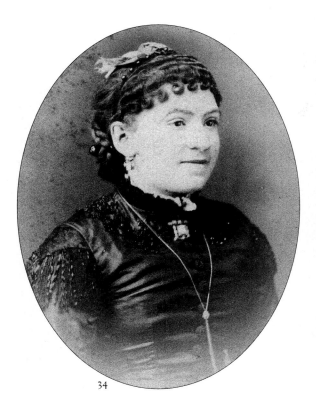

34

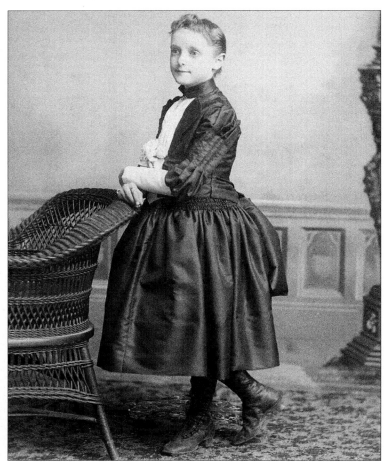

35

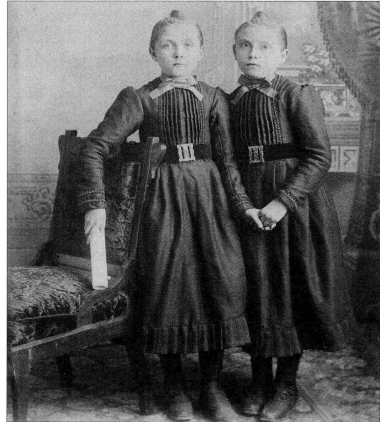

36

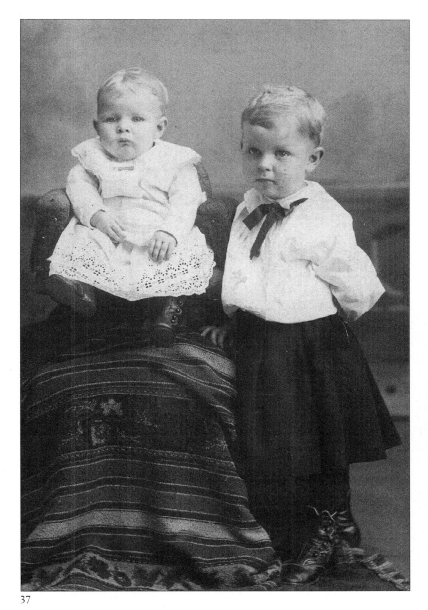

37

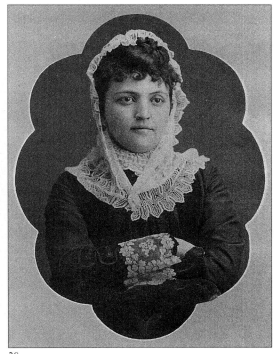

38

34. c.1870s. A woman whose dress is heavily trimmed with jet. ("*A. L. Paulus, Fredonia, Wis.*" CDV.)

35. c.1870. This girl wears a very fashionable dress that still has hoops under it, but is beginning to affect the bustle style. ("*E. W. Moore, Artist. Successor to Abell & Son. 29 Washington St., Portland, Or.*" Cabinet card.)

36. c.1870s. Twins dressed identically in severe dresses. (*Cabinet card.*)

37. c.1870s. The baby, sitting in a miniature armchair, wears a white dress—typical for boys and girls. The older child wears a skirt, which was typical for boys of his age. Notice the scalloped button boots on both children. ("*John T. Long, Jr. Artistic Photographer. Heller's Brick Block, Main St., Menomonie, Wis.*" Cabinet card.)

38. c.1870s. This woman shows off her lace cuffs and "fascinator," a type of headdress or head shawl. (*Cabinet card.*)

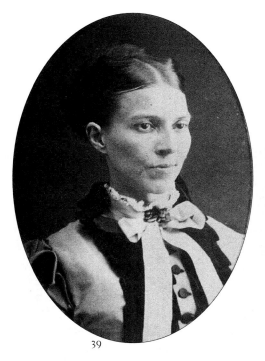

39

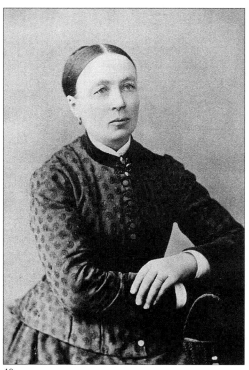

40

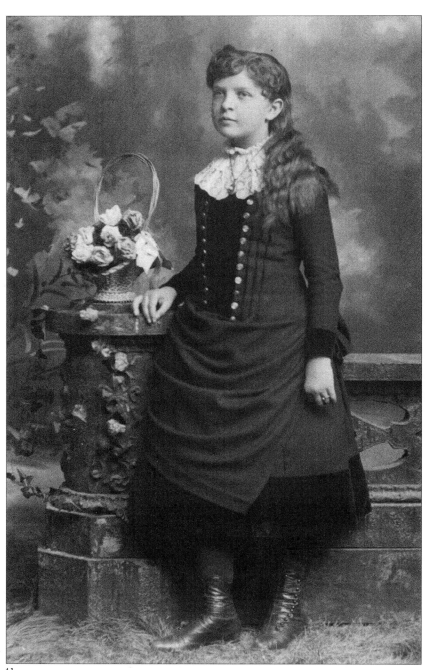

41

39. c.1870s. This woman's velvet-trimmed dress is typical of this epoch. (*"H. M. Phelps, Morgan, Ohio." CDV.*)

40. c.1870s. "[Miss or Mrs.] Sonstrom," dressed in jewelry and a modest print dress. (*"A. Larson, 313 Washington Ave., So., Minneapolis, Minn." Cabinet card.*)

41. c.1870s. A young girl wearing a typical dress trimmed with velvet. (*"Lundeluis, 124 Pike Street, Port Jervis, N.Y." Cabinet card.*)

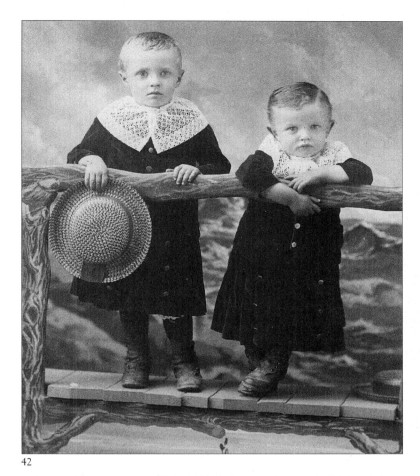

42

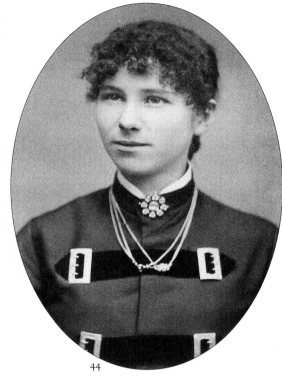

44

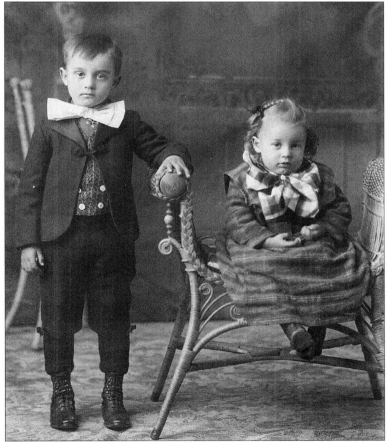

43

42. c.1870s. "Frank & Harvey McBride" wearing identical velvet lace-trimmed dresses. (*"Crawford, Albany, Oregon." Cabinet card.*)

43. c.1870s. A brother and sister dressed in unusually large neck bows. Notice how the girl's plaid bow clashes with her plaid dress. (*"The McGill Studios, Albion, Neb." Cabinet card.*)

44. c.1870s. This woman's bodice, like so many of this time, echoes military themes in its trimming. (*"L. M. Price, Photographer, Warren, Ohio. The old and Always Reliable Place." CDV.*)

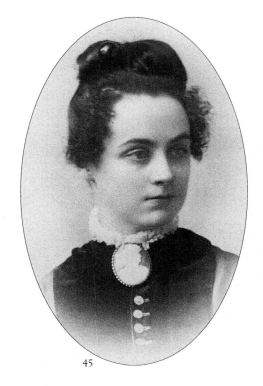

45

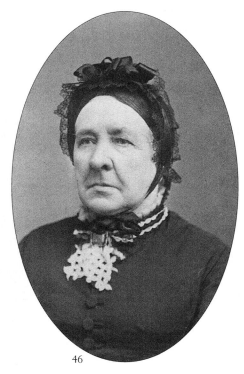

46

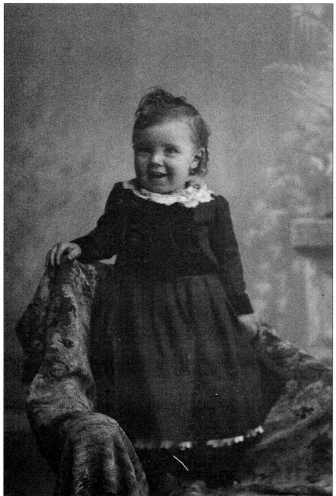

47

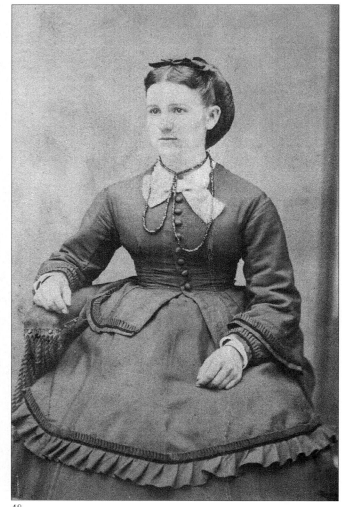

48

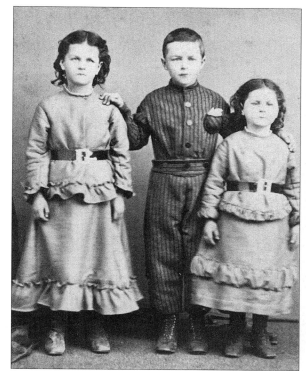

49

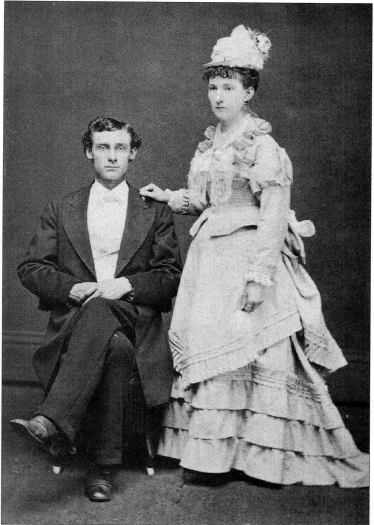

51

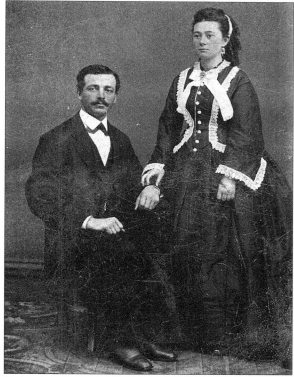

50

45. c.1870s. A lady in a prim bodice trimmed with a massive cameo. (*"Briggs & Co, The Ground Floor Studio, 311 E. Main Street, Ottumwa, Iowa."* Cabinet card.)

46. c.1870s. A woman wearing what was by then an old-fashioned widow's cap. (*"A. F. Salisbury, Photographer, 65 Mill Street, Pawtucket, R.I."* CDV.)

47. c.1870s. "Clarence Elwood Ankrum ('Nellie')," dressed in lace and velvet. (*"Bluitt, Kingsley, Iowa."* Cabinet card.)

48. c.1870. This woman wears a snood, along with her new-style overskirt and full sleeves. (*"T. Graham, Photographer, 93 Wood St., Pittsburg."* CDV.)

49. c.1870–73. The girls wear dresses that show decreased skirt size, and the boy wears a typical pants suit. Notice the photographer's body stands, which show at the children's feet. (*"Howland's Gallery, No. 359 First Street, San Jose, Cal."* CDV.)

50. c.1870. The woman wears a dress that is transitional between the hoop skirt and bustle, with wide sleeves and a rounded neck trimmed with a large bow. The man wears a typical suit. (*Tintype.*)

51. c.1870–71. The gentleman wears cuffed trousers, while the lady wears a very fashionable dress and hat. Notice how her feet appear to have been wiped out of the picture, so that she "floats." (*"O. W. Detwiler, Portrait Photographer, Canton, Mo."* CDV.)

52. c.1871–72. A fashionable couple. The man wears a well-tailored suit with a thick tie, while the woman wears a fine dress featuring small puffed oversleeves above long, slim undersleeves. (*"Edy & Co., Artistic Photographers. Colborne St., Brantford."* CDV.)

53. c.1874–76. A typical bride and groom. Like many Victorian brides, she wears, not a white gown, but what is her "best" dress. (*"Joseph J. Cramer, Photographer, Grafton, Wis."* CDV.)

54. c.1873–74. "Callie," dressed in a rich and fashionable dress. (*Cabinet card.*)

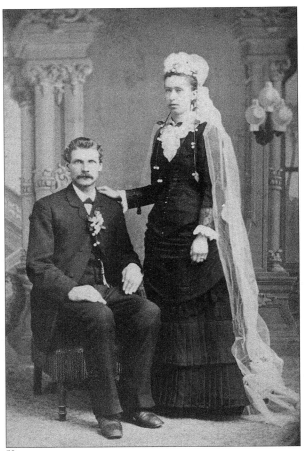

53

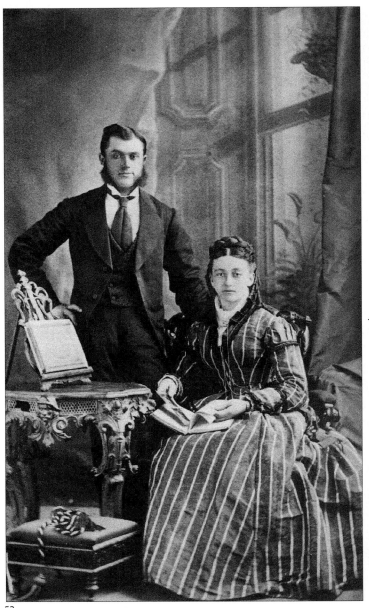

52

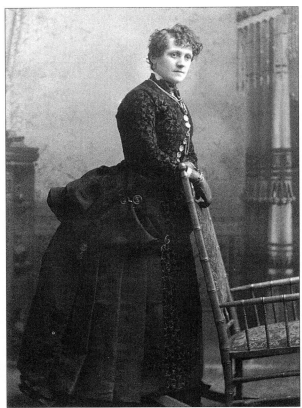

54

55

55. c.1874–75. A woman in a typical early bustle dress. (*"Moore, 141 & 143 S. Howard St., Akron, O."* Cabinet card.)

56. c.1875–1876. Although wearing a fashionable dress trimmed with ruching and wide cuffs, this woman wears her hair unfashionably in a braid. (*"L. Sherman, No. 18, West Main St., Rochester, N.Y."* Cabinet card)

57. c.1875–78. An older woman, dressed fashionably in a tasteful dress, with mitts and fan. (*"Reed, 210 Fifth Avenue, Clinton, Iowa."* Cabinet card.)

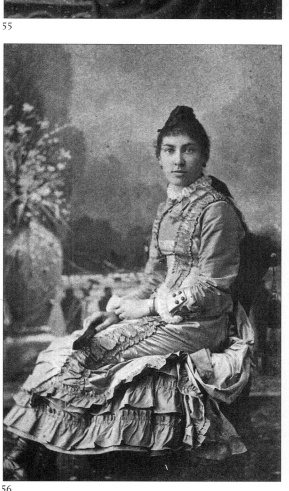

56

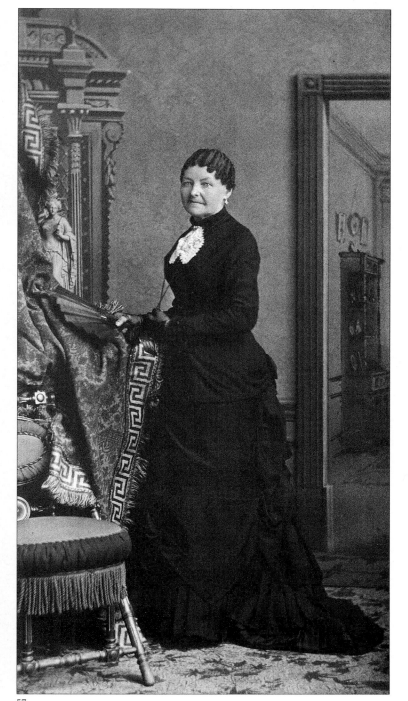

57

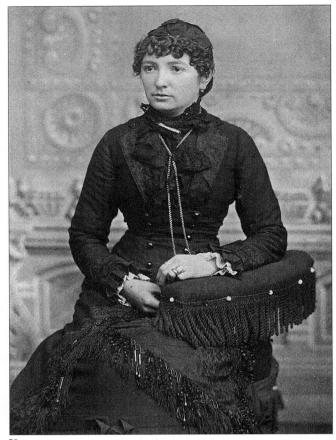

58

58. c.1876. "Miss Sadie Ross, Oxford, Indiana," in a dress elaborately trimmed with jet fringe. (*Cabinet card.*)

59. c.1877–80. A woman in a simple but fashionable dress. ("*J. F. Miller, Photographer, Battle Creek, Michigan.*" *Cabinet card.*)

60. c.1877–80. "Lydia Steeves, wife of Aaron Steeves, mother of Dr B. L. Steeves," is dressed in good taste: her dress follows fashion's lines, and is trimmed effectively and simply. (*CDV.*)

61. c.1877–80. A young lady dressed in a very modest, but fashionably cut, dress. ("*O. A. Dolph, Photographer, Rock Creek, Ohio.*" *CDV.*)

62. c.1876. Despite her grim expression, this lady wears a suitably fashionable dress with a nearly bustleless double skirt and long fitted bodice. ("*Macy, Vinton, Iowa.*" *CDV.*)

63. c.1876–77. A lady in a fashionably trained gown. ("*Photographic Studio of Coleman's Art Gallery. M. O. T. Coleman, Westfield, Mass.*" *Cabinet card.*)

64. c.1877–81. This woman wears a fashionable coat, lace scarf, gloves, and hat. ("*Smith, East End Gallery. 505 Central Avenue, Minneapolis.*" *Cabinet card.*)

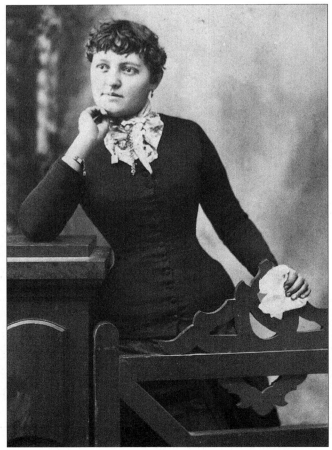

59

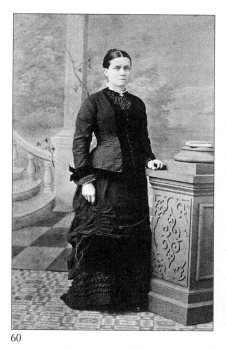

60

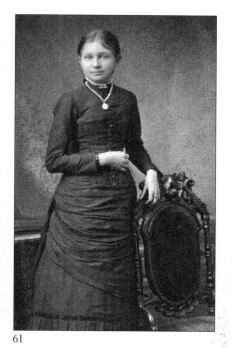

61

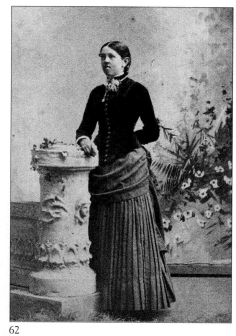

62

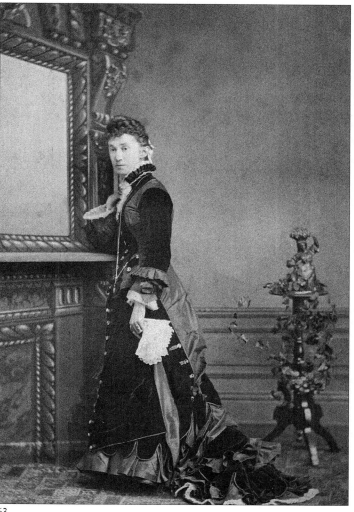

63

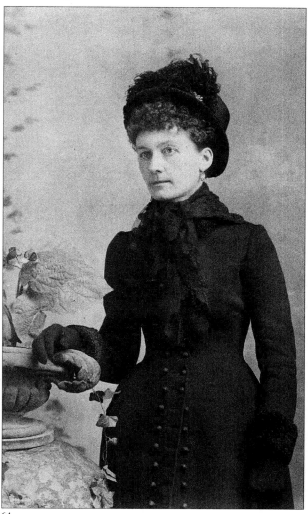

64

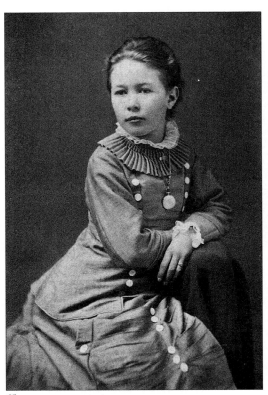

65

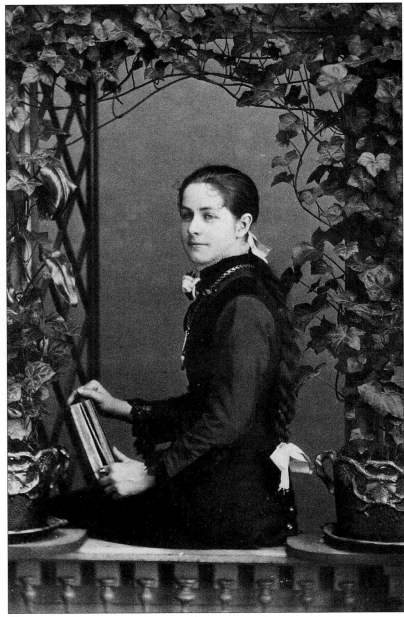

67

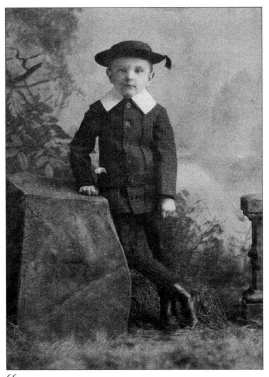

66

65. c.1878. This young lady, photographed on Dec. 9, 1878, wears a dress trimmed with lace, pleating, and large buttons. (*"From O. A. Dolph's Art Studio, Rock Creek, Ohio." CDV.*)

66. c.1878–80. A boy dressed in a jaunty and fashionable suit. (*"Davies, Photographer, cor. First & Taylor Sts, Portland, Oregon." CDV.*)

67. c.1878–80. "Eva Bergbank" in a very fashionable costume. On the back of the photo is the sad note: "Drowned 2/6/93." (*"San Francisco Gallery, Buchtel's Old Stand, W. H. Towne, Artist, Cor. First & Morrison Sts., Portland, Ogn." Cabinet card.*)

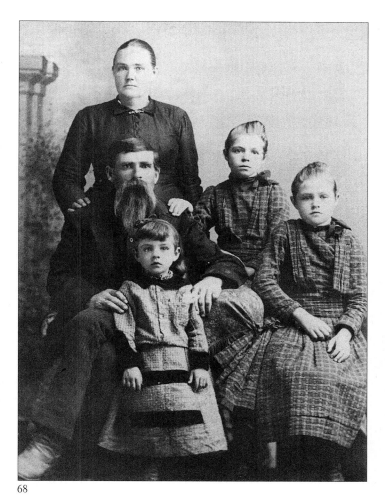

68

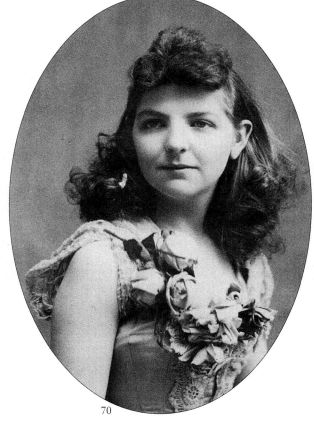

70

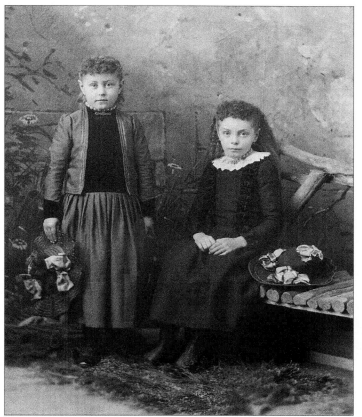

69

68. c.late 1870s. This family is dressed in a modest fashion, with the two sisters wearing matching dresses. The boy wears a dress typical for boys of the period, but quickly going out of style. ("*E. Graves, Photographic Art Studio, Osceola, Iowa.*" Cabinet card.)

69. c.1879–82. Sisters clothed in fashionable dresses, scalloped boots, and hats. ("*Crawford & Paxton, Froman's Block, Albany, Oregon.*" Cabinet card.)

70. c.1880. "Frixy Kinedy" wearing a teen's evening dress. ("*Beedy, Postville, Iowa.*" Cabinet card.)

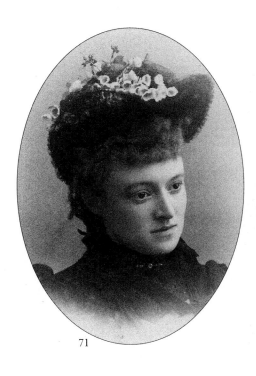

71

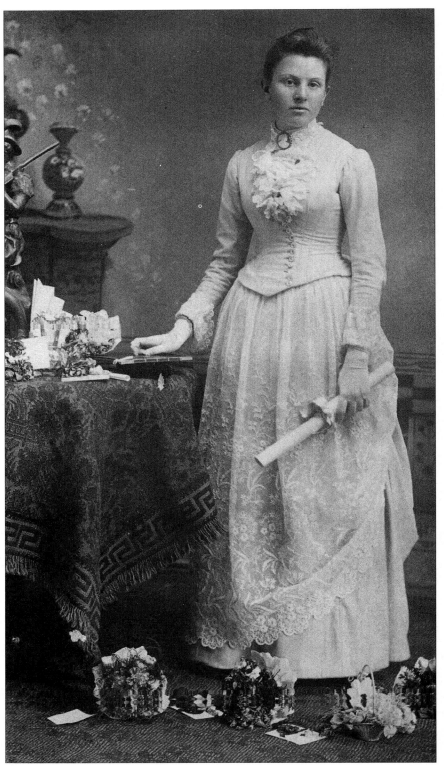

72

71. c.1880s. A woman wearing a beaver hat trimmed with faux flowers. (*"Rogers, Olympia, Wash."* Cabinet card.)

72. c.1880s. A young woman in what appears to be her graduation dress. Notice the looped lace overskirt and the large cameo at her neck. (*"A. W. Warrington, Oskaloosa, Iowa."* Cabinet card.)

73. c.1880s. A child modestly dressed in a relatively simple lace-trimmed dress. (*"Wright, 24 West Santa Clara Street. San Jose Cal."* Cabinet card.)

74. c.1880s. Three women of little means wearing very plain dresses for their era. (*"Wharton, Winamac, Ind."* Cabinet card.)

75. c.1880s. A boy in a typical suit worn with a cravat, cap, and buttoned shoes. (*"Phillip Hupp, Waitsburg, Wash."* Cabinet card.)

76. c.1880s. A girl fashionably dressed in a velvet-and-lace dress, flowers, high button boots, and a ring. (*"Healy, Afton & Murray, Iowa."* Cabinet card.)

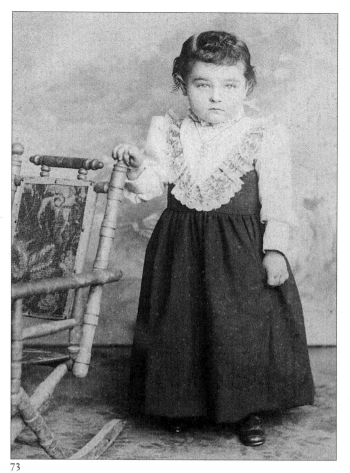

73

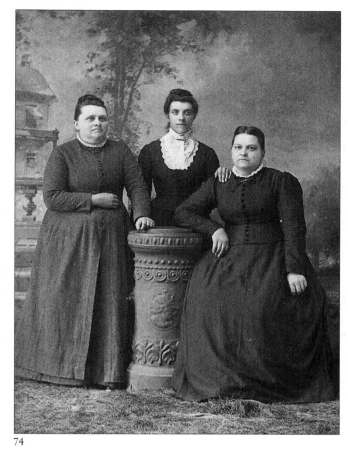

74

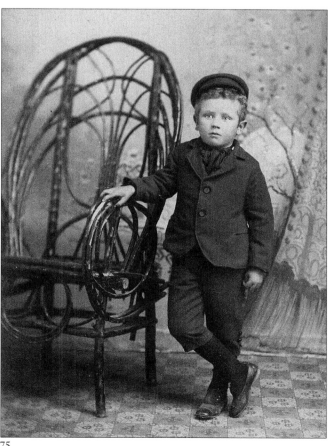

75

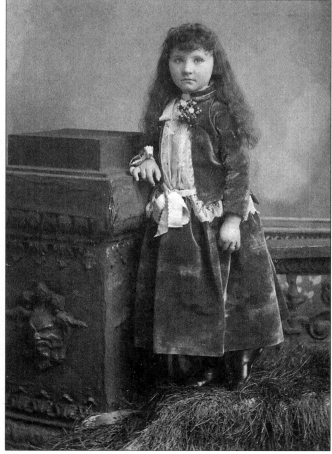

76

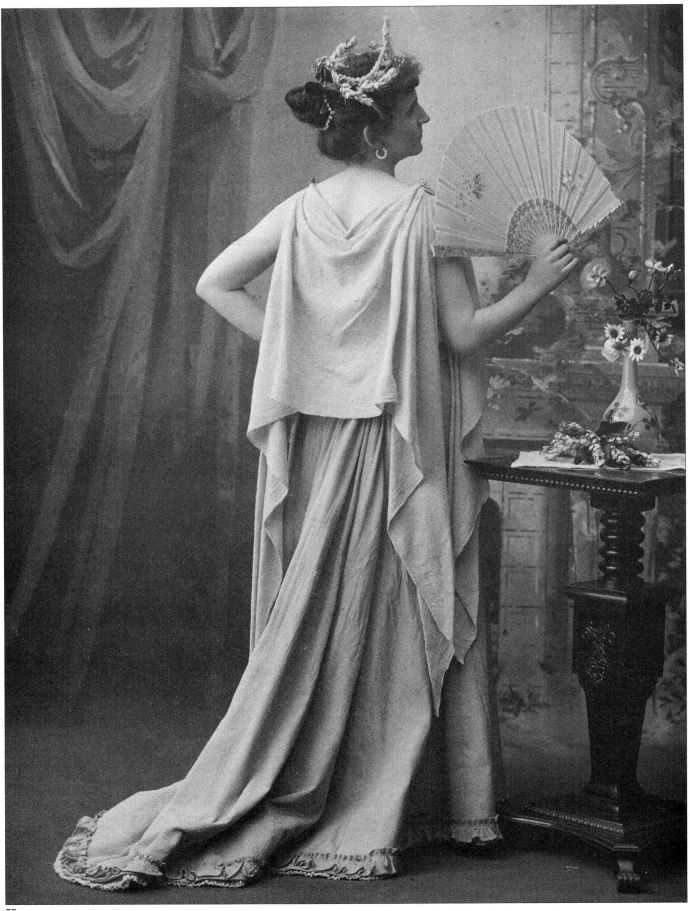

26

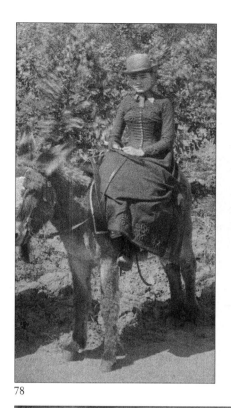

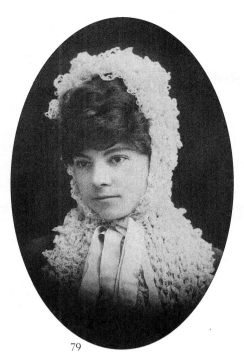

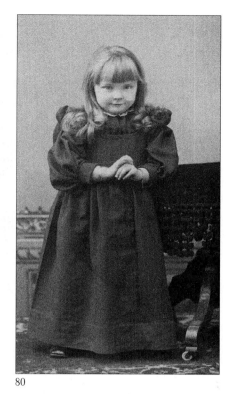

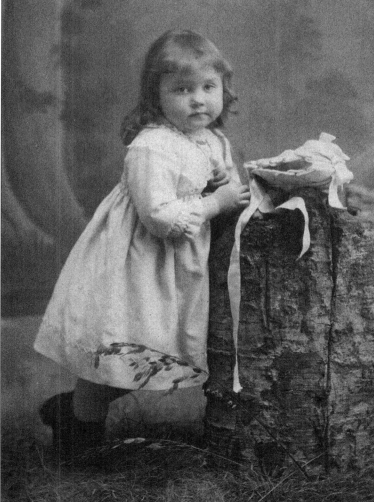

77. c.1880s. A woman wearing what may be an extreme reform costume, but more likely is a fancy dress costume in the Grecian style. (*"Heyn, Omaha, Neb." Cabinet card.*)

78. c.1880s. A woman in a riding habit. (*"McLellan . . . California." Cabinet card.*)

79. c.1880s. A young woman wearing a handmade "fascinator." (*"Stowe & Woods, Clark Block, Fayette, Mo." Cabinet card.*)

80. c.1880s. "Gretchen – three years old," wearing a very simple dress (notice her jewelry, though). (*"D. Marsh, Kendrick, Idaho." Cabinet card.*)

81. c.1880s. "Agnes Coate" wearing a simple toddler's dress. (*Cabinet card.*)

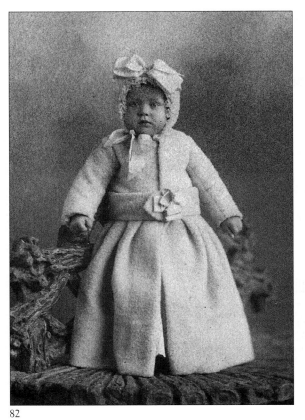

82

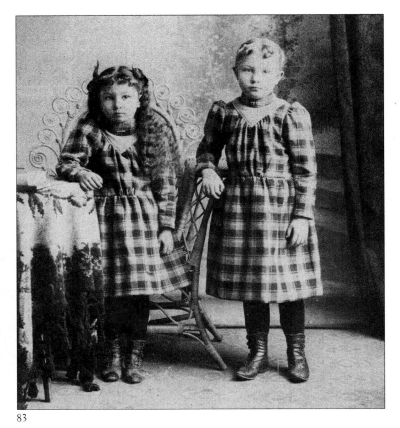

83

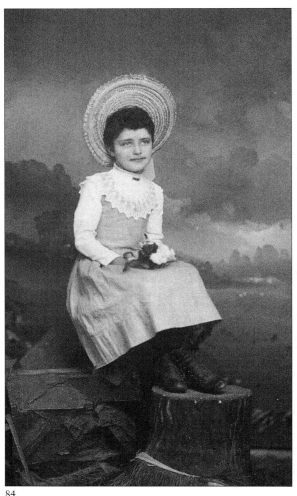

84

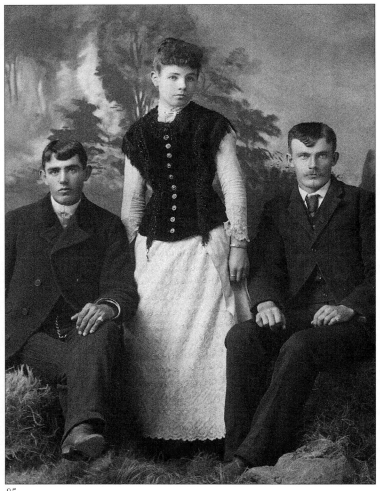

85

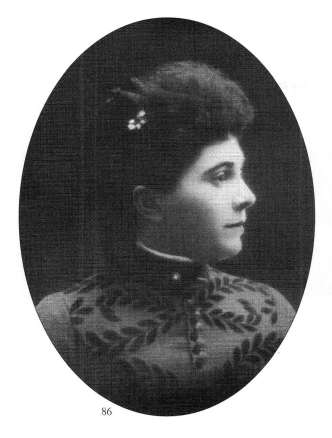

86

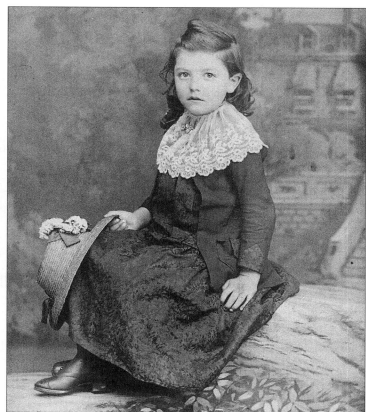

87

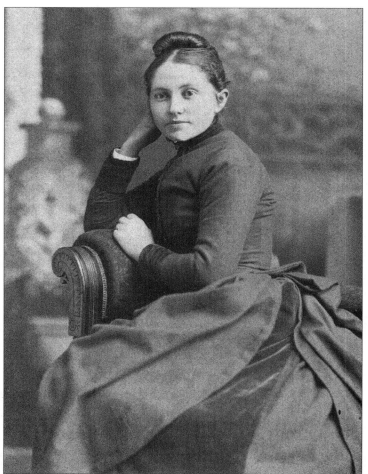

82. c.1880s. A baby who brings to mind the old nursery rhyme "Baby Bunting," covered head to toe in a warm bonnet and coat. ("*J. A. Brush, Artistic Photographer. Hennepin Ave and 6th St., Minneapolis, Minn.*" Cabinet card.)

83. c.1880s. Sisters dressed identically in plaid dresses and button boots. ("*E. O. Hover, Flandreau, S.D.*" Cabinet card.)

84. c.1880s. This girl's dress is simple, despite its lace trim. With it she wears a large straw hat and high button boots. ("*DeMoulin, Greenville, Ills.*" Cabinet card.)

85. c.1880s. This group is dressed in everyday attire. The vestlike bodice the young woman wears over her white dress is unusual. ("*Winter Photo Company, Eugene, Oregon, U.S.A.*" Cabinet card.)

86. c.1880s. This lady wears a gown ornamented chiefly with appliqué. (*Overpainted silver print on canvas-textured paper.*)

87. c.1880s. A girl from a fashionable family, with a wide lace collar, carefully done hair, and stylish hat. ("*A. Hassan, Glencoe, Minn.*" Cabinet card.)

88. c.1880s. "Lydia Mathewson Swanson" dressed quite elegantly, though simply, for her era. ("*Glines, 6 Winter St., Cor. Washington, Boston, Mass.*" Cabinet card.)

88

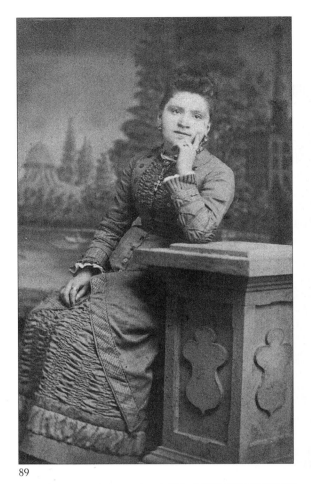

89

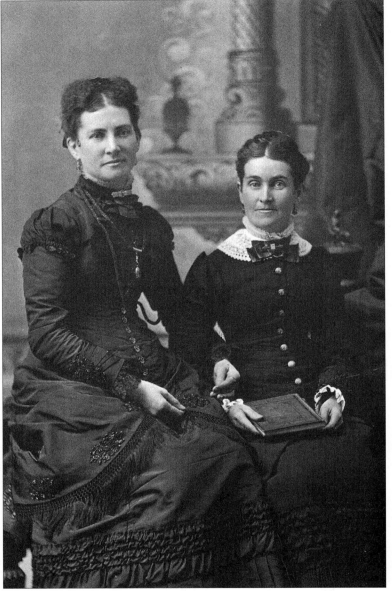

91

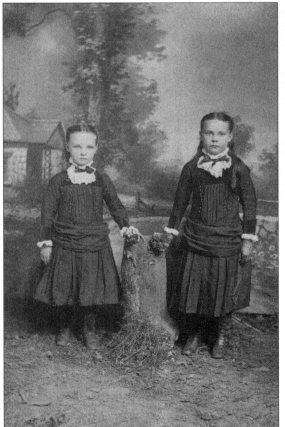

90

89. c.1880–81. This young woman wears a dress trimmed with ruching—a popular fabric treatment at the time. (*"A. L. Paulus, Fredonia, Wis." CDV.*)

90. c.1880–82. Sisters were often dressed identically, as these young girls were, in their fashionable, dropped-waist dresses. (*Cabinet card.*)

91. c.1880–82. "Mary Eckstine [and] Hattie Bruce, Sisters. 1880." Two well-dressed ladies. The woman on the left wears jet, fringe, and extensive ruching on her dress, while the woman on the right is more subtly dressed. (*"Pooley, Galena, Ills." Cabinet card.*)

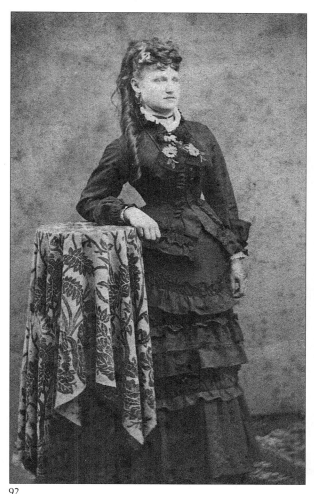

92

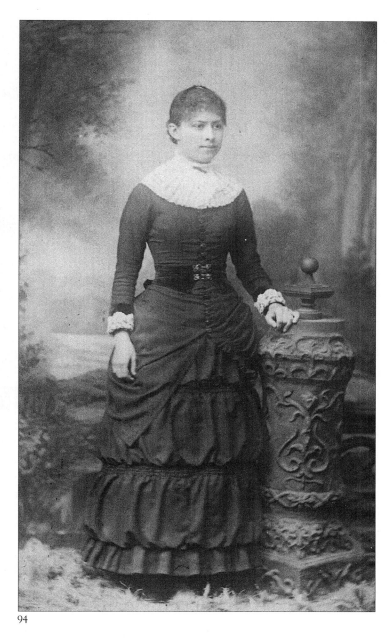

94

93

92. c.1881. "Rosie Geipce" is fashionably dressed, although her hairstyle, which indicates an evening occasion, is highly unusual. (*CDV.*)

93. c.1880–84. Hats suddenly grew large in the early 1880s, and this woman's ostrich feather millinery is a classic example. (*"Ribble, St. Peter, Minn." Cabinet card.*)

94. c.1882. A young woman wearing an elaborate everyday dress. (*Cabinet card.*)

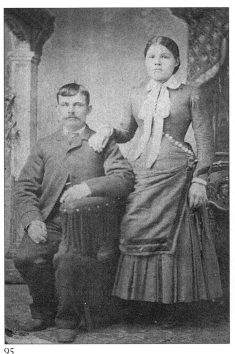

95

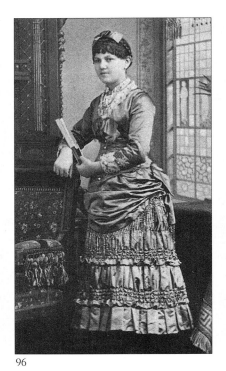

96

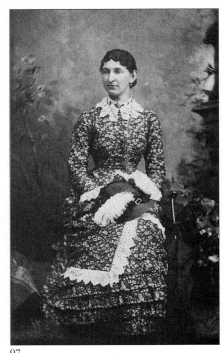

97

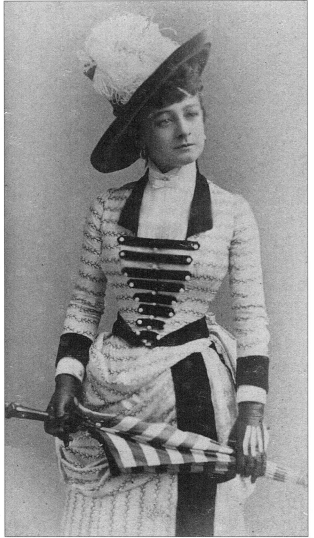

98

95. c.1882. This young woman wears a fashionable dress in the tunic style, with an underskirt of pleating. The young man wears a typical suit. (*CDV.*)

96. c.1882–83. A young lady in a highly fashionable ruched bustle dress. Her short skirt indicates that she was not yet 18. ("*Klotter & Scherer Photograph Art Gallery, 906 & 908 N. 6th St., St. Louis, Mo.*" *CDV.*)

97. c.1883. A very fashionable woman in a printed dress trimmed with lace, and a plumed hat. (*CDV.*)

98. c.1882–87. An actress in a stunning costume that makes wonderful use of stripes. (*CDV.*)

99. c.1882–83. A charmingly dressed young lady wearing a white lace bustle dress, wide-brimmed straw hat, mitts, and carrying a fan and parasol. ("*W. J. Kilborn, Grand Island, Neb.*" *Cabinet card.*)

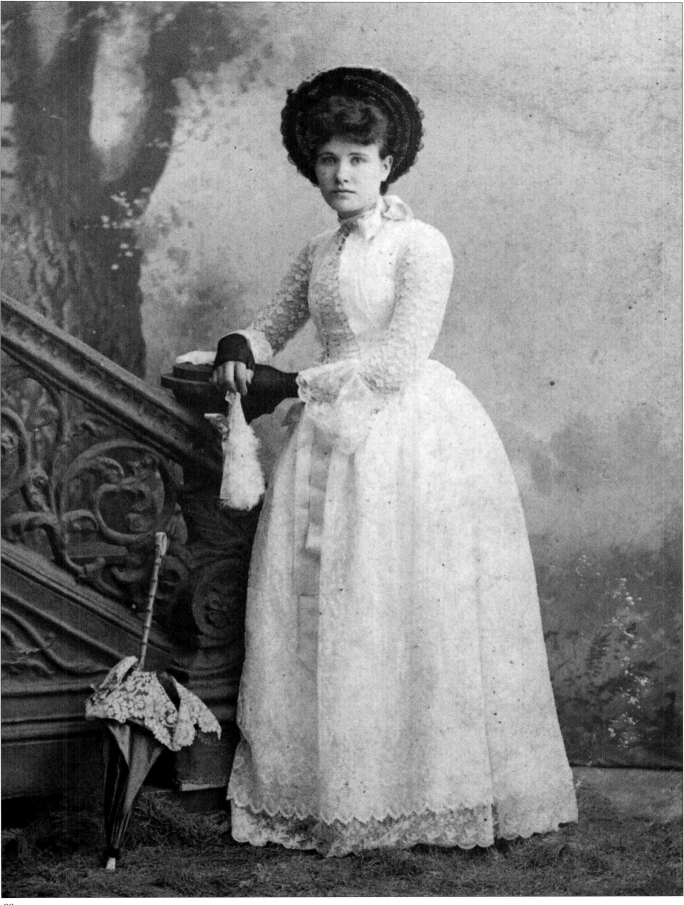

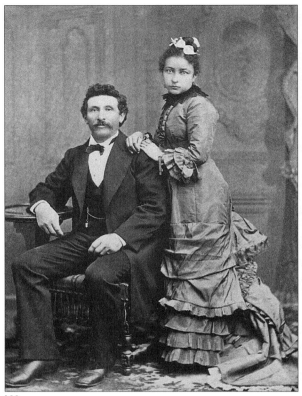

100

102

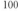

101

100. c.1884. This man wears a stylish suit, while the woman is dressed in a wrinkled, but nonetheless fashionable, dress. (*"Edouart & Cobb, No. 504 Kearny St., San Francisco." Cabinet card.*)

101. c.1883. The cut of this woman's dress is in keeping with the fashion of her time, but its simple trimming is unusual. (*"L. M. Swops, Perry, Iowa." Cabinet card.*)

102. c.1883. This man wears an ordinary suit, while the woman wears a more fashion-conscious dress trimmed with jet. Notice how her bodice wrinkles between her arm and her breast; most dressmakers placed padding in that area to prevent tight bodices from doing just that. (*"Thwaites, Photographer, 167 & 169 First St., Portland, Or." Cabinet card.*)

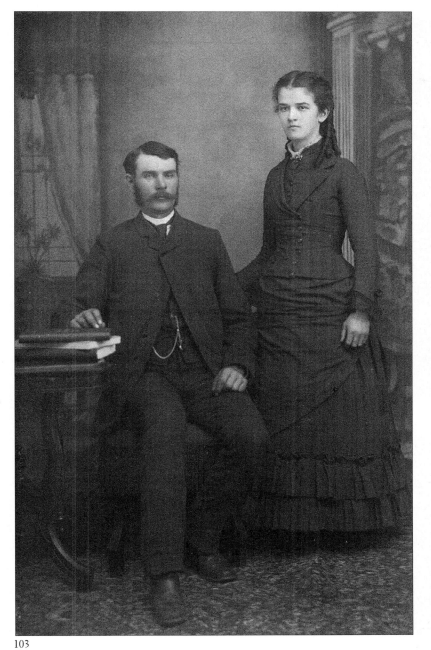

103

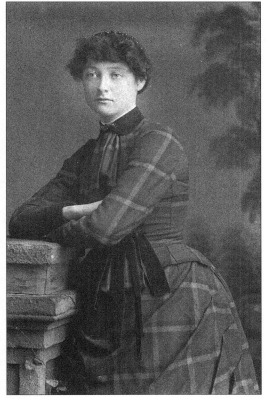

104

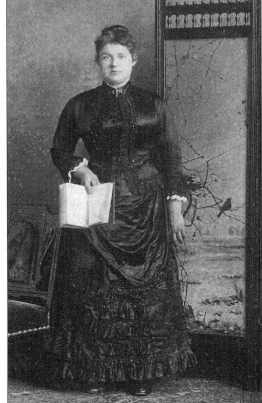

105

103. c.1883. "J. L. McGee . . . and first wife Minnie," dressed in reasonably fashionable, yet modest, attire. ("*Mary Weigel, Artist, Dyersville, Iowa.*" *Cabinet card.*)

104. c.1883–84. A woman wearing then-popular plaid. ("*Udell, Three Rivers, Mich.*" *Cabinet card.*)

105. c.1883–84. A lady in a fashionable dress trimmed with jet and ruffles. ("*Partridge's Western Headquarters, Opposite the Post Office, Portland, Oregon, U.S.A. E. J. Partridge, W. H. Partridge.*" *CDV.*)

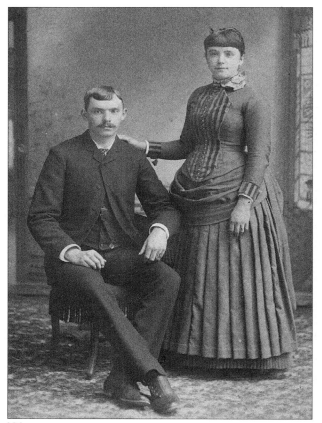

106

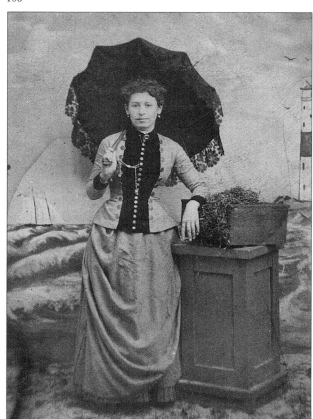

107

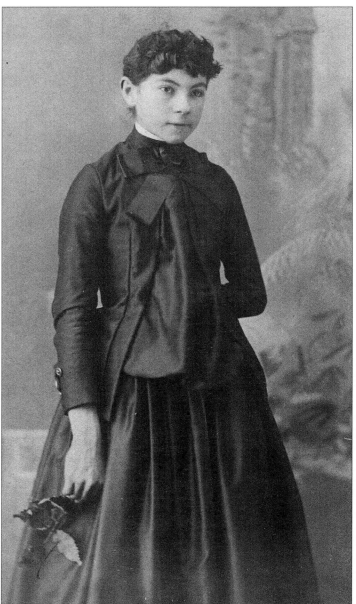

108

106. c.1883–85. "Mary Audes & Henry Blocker" dressed in typical everyday attire. Note the man's buttoned shoes. ("*S. K. Pannebecker, Nanticoke, Pa.*" Cabinet card.)

107. c.1884. This woman is dressed in an artfully draped skirt and long bodice, and carries a lace-trimmed parasol. (*Tintype.*)

108. c.1884. "May McMorris" wearing a style of dress that lasted less than a year. Many "reform"-style costumes were similar—although, interestingly enough, less extreme in their loose bodices. The bodice style is also reminiscent of the pigeon bodice of the turn of the century. ("*Macurdy, Fayette, Mo.*" Cabinet card.)

109. c.1884–85 A fashionable woman in a white bustle dress, with hat, lace parasol, and fan (hanging on the gate). ("*Crawford & Paxton, Albany, Ogn.*" Cabinet card.)

110. c.1885. A woman dressed to the nines with a draped bustle dress, fur-trimmed cape, and plumed shepherdess hat. ("*J. Haws, Decatur, Ill.*" Cabinet card.)

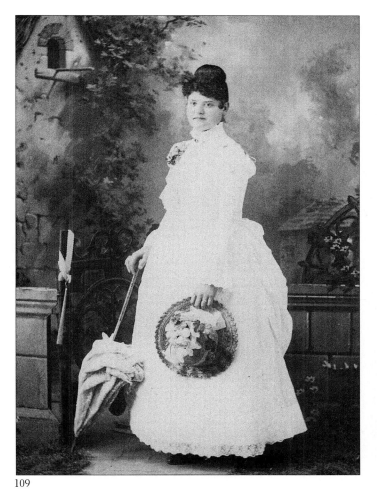

109

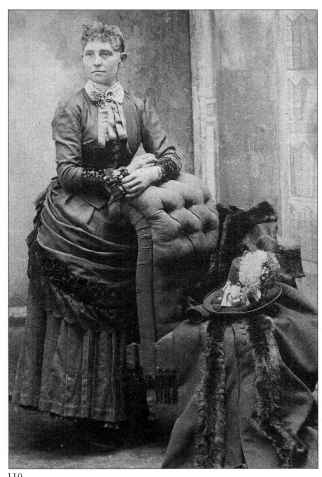

110

111. c.1885–87. A fashionable lady with the latest tall millinery, a jet- and braid-trimmed dress, and tight gloves. (*Tintype.*)

112. c.1885–1889. A smartly dressed woman in a wool dress trimmed with covered buttons, braid, and several articles of jewelry. (*"Westervelt, 18 South Main Street, Los Angeles, Cal." Cabinet card.*)

113. c.1886. A boy dressed in Little Lord Fauntleroy style. (*"Davies, N.W. cor. 3rd & Morrison, Portland, Or." Cabinet card.*)

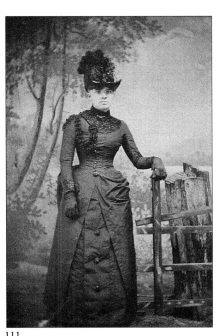

111

112

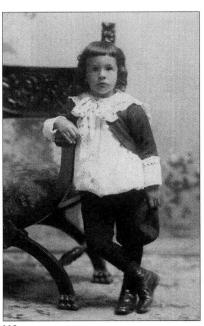

113

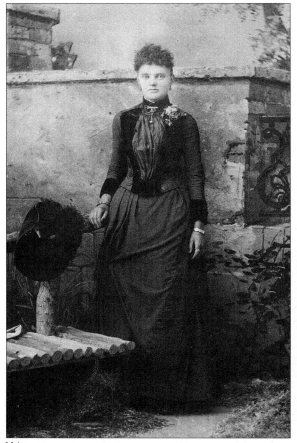

114

115

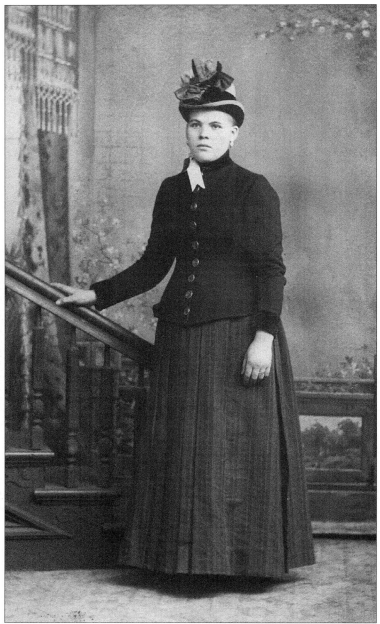

116

114. c.1887–88. "Sela Bilien, Schoolmate," decked out with jewelry, a fashionably plumed hat, and a dress trimmed with velvet. Asymmetrical skirt treatments were common during these years. (*Cabinet card.*)

115. c.1887–88. "Seth Smith" wearing an everyday suit and a bowler hat. ("*Gehrig Studios, Frank A. Place, Proprietor. 337 West Madison Street, Chicago.*" Cabinet Card.)

116. c.1887. This woman is dressed modestly for her time, but her costume follows stylish lines. Her jacket is fitted and cut well below the hips, her skirt is semi-tailored, and her hat is in the small but high style. ("*From the Photographic Studio of O. C. Burdick, 301 Washington Ave., S., Minneapolis, Minnesota.*" Cabinet card.)

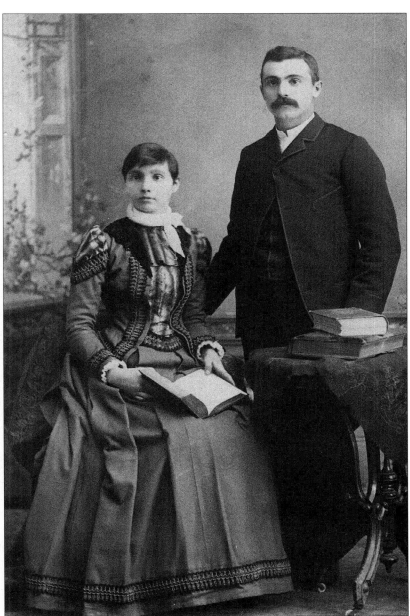

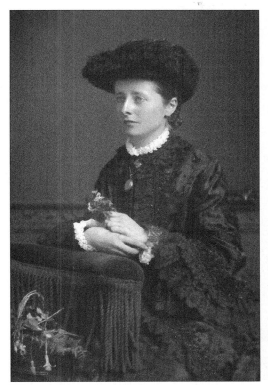

117

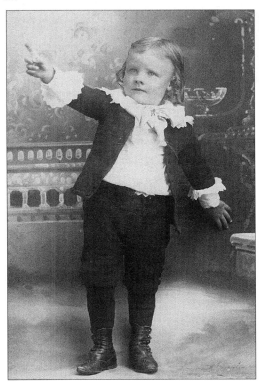

118

119

117. c.1887–88. A fashionable young woman in a full-sleeved lace paletot and feathered hat. ("*Walter Tully, Station Rd, Glastonbury.*" *CDV.*)

118. c.1886–89. Another boy in a Little Lord Fauntleroy-inspired suit. ("*Parker's Studio, Baker City, Oregon.*" *Cabinet card.*)

119. c.1887–89. The man wears a plain suit with bias binding trim, while the woman wears a dress elaborately trimmed with braid and contrasting fabric. ("*F. M. Ingalls. Missoula, Mont.*" *Cabinet card.*)

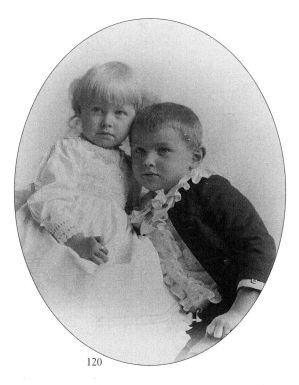

120

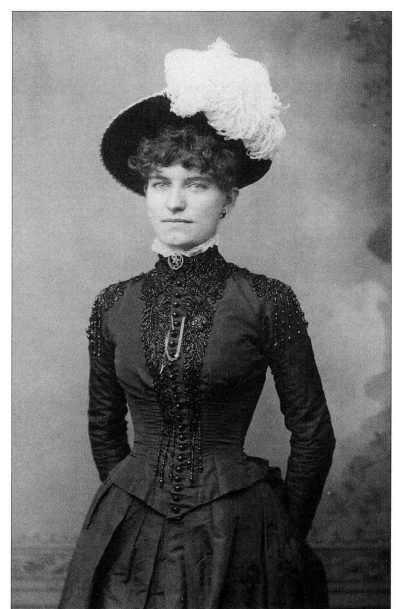

122

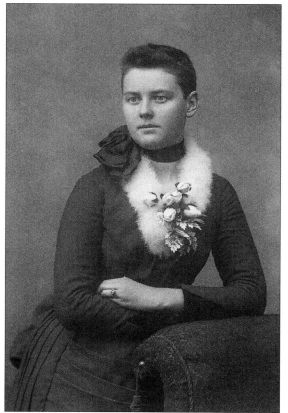

121

120. c.1888–89. The baby here is dressed in a white dress trimmed with crochet "lace," while the boy wears a Fauntleroy-style suit. (*"J. A. Brush, Artistic Photographer, Hennepin Ave. & Sixth St., Minneapolis, Minn." Cabinet card.*)

121. c.1888. "Eella Press" in a dress that has unusual marabou feather trim. (*"Swem, Cottage Gallery, Cedar Rapids, Iowa." Cabinet card.*)

122. c.1888. "Jennie Fisher" dressed in lavishly jet-beaded attire, with a highly fashionable plumed hat. (*"Swem, Cottage Gallery, Cedar Rapids, Iowa." Cabinet card.*)

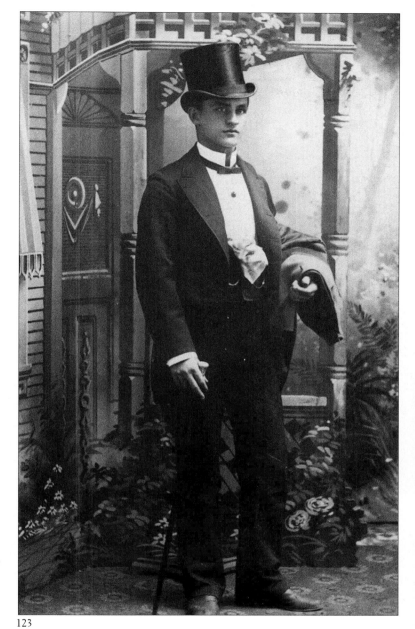

123

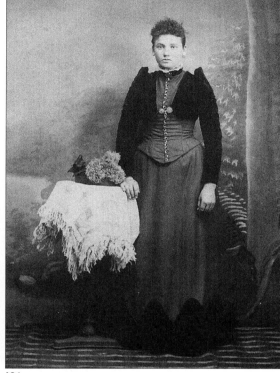

124

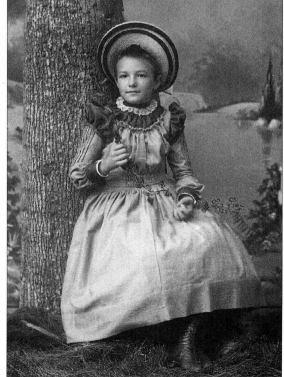

125

123. c.1888. "Billie[?] Marshall" in evening attire. ("*S. A. Johnson, Artist, Phillips, Wis.*" Cabinet card.)

124. c.1889. "Annie Earle" attempting to look fashionable, and coming close, but missing. Her sleeves are too high and pointy, her bodice too wrinkled, and her dress trimmed too plainly. (*Cabinet card.*)

125. c.1889–1890. This girl's double sleeve and smocked waistline are typical of the era. Note the wide hem, allowing for growth. ("*Barnum, Morrison, Ill.*" Cabinet card.)

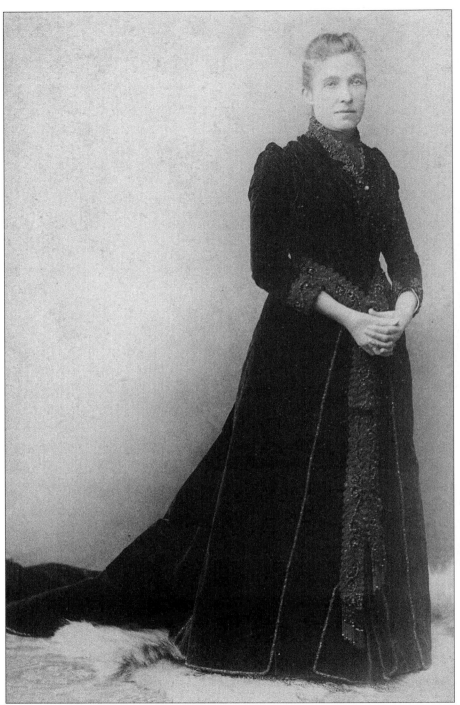

126

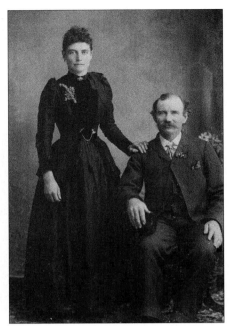

127

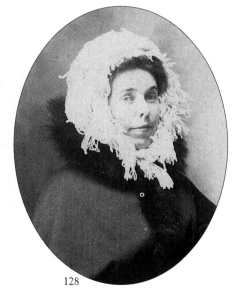

128

126. c.1889–91. A stunningly dressed woman whose velvet gown is trimmed with jet. (*"Heyn, 313, 315 and 317 S. 16th St. Omaha." Cabinet card.*)

127. c.1889–90. "Mom & Perry Olinghoose." The woman wears a beautiful and fashionable dress, the man a typical day suit. (*"Hutchings." Cabinet card.*)

128. c.late 1880s–early 1890s. A woman draped in a fur-trimmed cloak and wearing a "fascinator." (*Cabinet card.*)

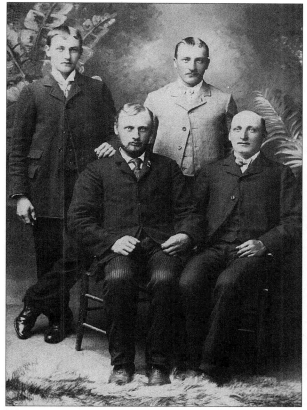

129

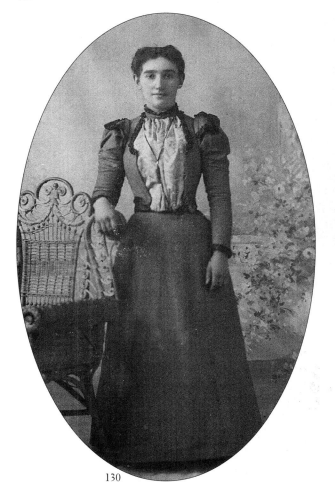

130

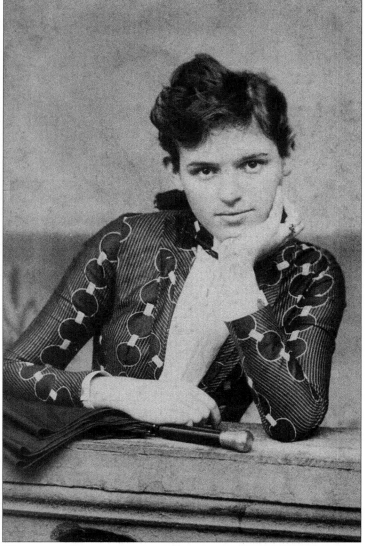

131

129. c.late 1880s. Men wearing typical everyday suits of the era. (*"Bell & Co., Astoria, Or." Cabinet card.*)

130. c.1889–90. This woman wears the classic day dress of these years, whose bodice would later inspire styles of the late 1890s. (*"Barnes, New Bethlehem, Pa." Cabinet card.*)

131. c.1888–90. A teenage girl with a fashionably printed dress and a parasol. (*"From the Photographic Studio of P. M. Tilghman, Crisfield, Md." Cabinet card.*)

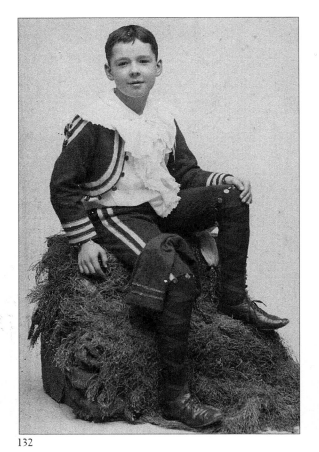

132

133

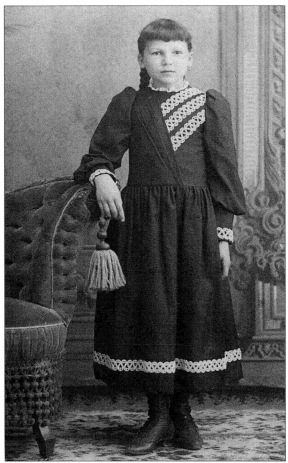

134

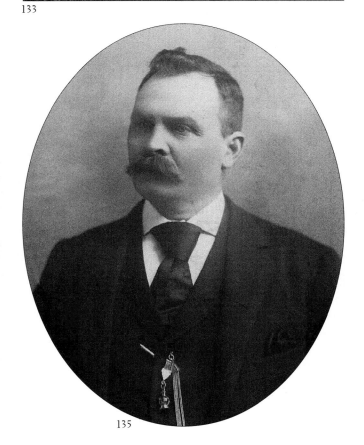

135

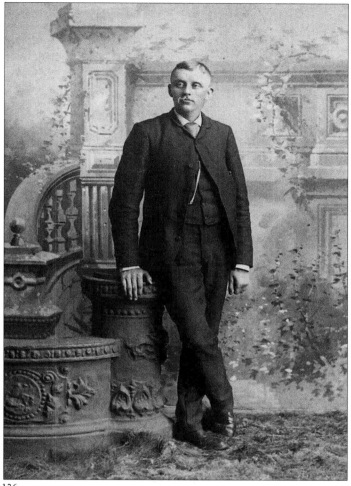

136

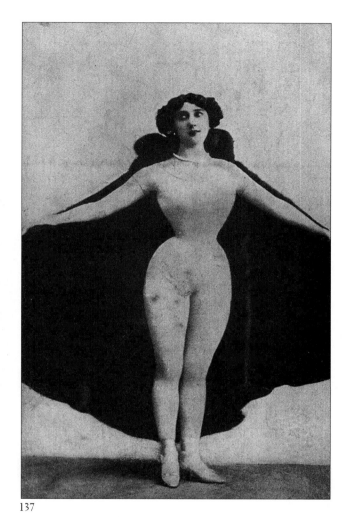

137

132. c.late 1880s. A boy in a fashionable military-inspired suit, with hints of the Little Lord Fauntleroy style. (*"McAlpin and Lamb, Dekum Bldg, Portland, Or."* Cabinet card.)

133. c.late 1880s–early 1890s. "Tishie" wears an ill-fitting everyday outfit of checkered trousers, vest, and bow tie. (*"Hopps' Art Co., Little Rock, Ark."* Cabinet card.)

134. c.1889–91. A girl wearing an everyday dress trimmed with braid, and high button boots. (*"Roberts & Stoddart, Photographers. Successors to Fowler & Co. Peach and 10th, Erie, Pa."* Cabinet card.)

135. c.1880–1890. "[Mr.] Carlson," a middle-class gentleman wearing the wide tie and watch fob of his era. (*"A. Larson, 313 Washington Ave. S., Minneapolis."* Cabinet card.)

136. c.late 1880s–early 1890s. A gentleman wearing a conservative suit. (*"Oswald Bros, 1227 & 1229 Washington Ave. N., Minneapolis, Minn."* Cabinet card.)

137. c.1890s. A theatrical performer in a scandalously revealing bodysuit that exposes an incredibly tightly corseted waist. (*Postcard.*)

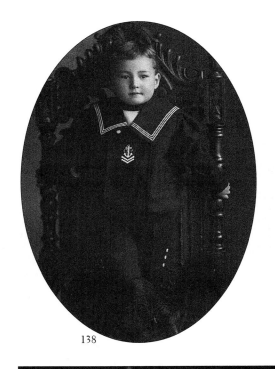

138

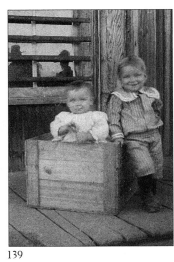

139

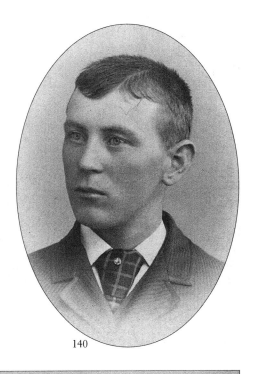

140

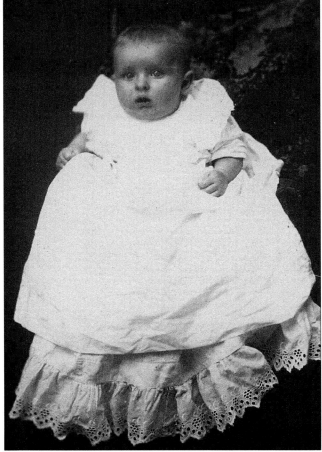

141

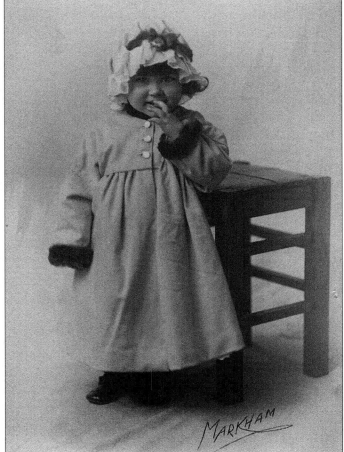

142

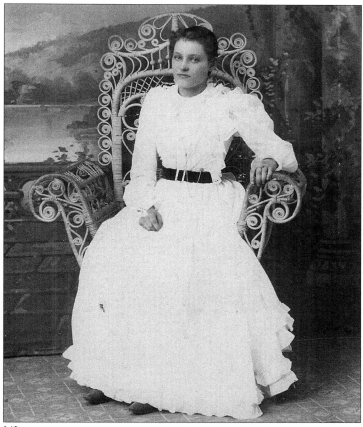

143

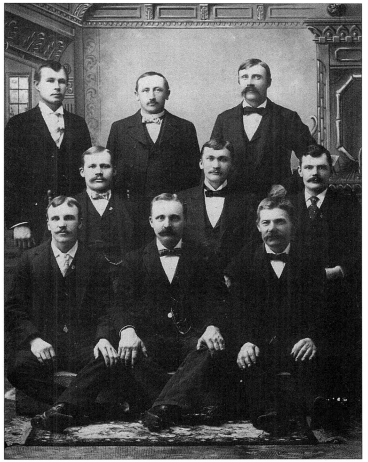

144

138. c.1890s. A little boy fashionably dressed in a sailor suit. (*"Lucerne Studios, Dekum Bldg., Portland, Ore."* Cabinet card.)

139. c.1890s. Toddlers in play attire. (*Cabinet card.*)

140. c.1890s. A young man in a typical suit with a plaid tie. (*"Photographic Studio of O. C. Burdick, 301 Washington Ave. S., Minneapolis, Minn."* Cabinet card.)

141. c.1890s. A baby in the typical white "long" dress of the period. (*Cabinet card.*)

142. c.1890s. "Adarain Davis, Wilbert's & Margurite's Daughter," in a mob cap and fur-trimmed coat. (*"Markham." Gelatin print.*)

143. c.1890s. A young woman in a white eyelet-trimmed dress with a dark velvet belt. (*"Jensen Bros., Albert Lea, Minn."* Cabinet card.)

144. c.1890s. A group of men wearing the typical suits of the era. (*"Math Mathson, Astoria, Ore."* Cabinet card.)

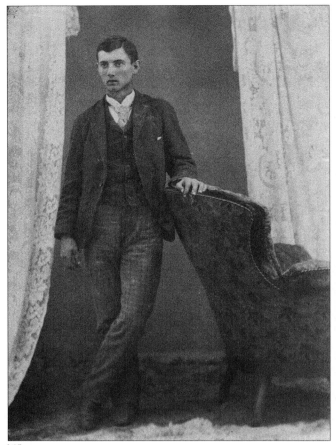

145

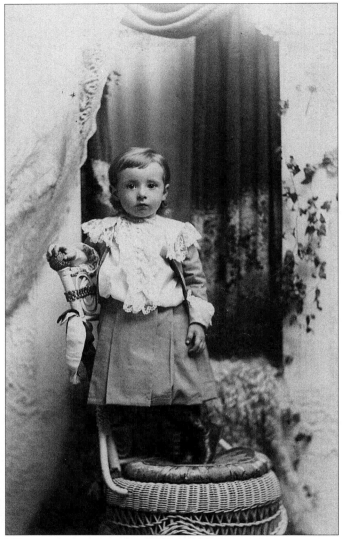

147

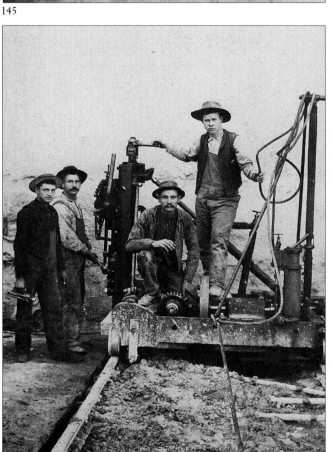

146

145. c.1890s. A young man in a casual suit. (*Cabinet card.*)

146. c.1890s. Men at work, wearing wide-brimmed felt and straw hats, overalls, shirts with full sleeves, and vests. (*Cabinet card.*)

147. c.1890s. This boy wears a typical pleated skirt and a ruffled blouse. (*"Davies, N.W. Cor. 3rd & Morrison, Portland, Or." Cabinet card.*)

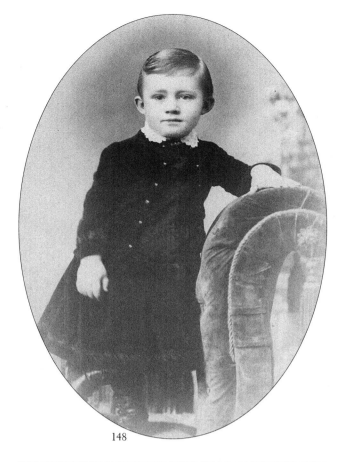

148

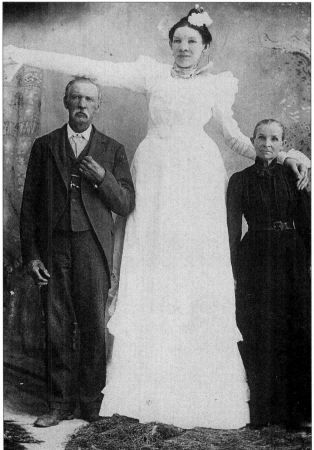

149

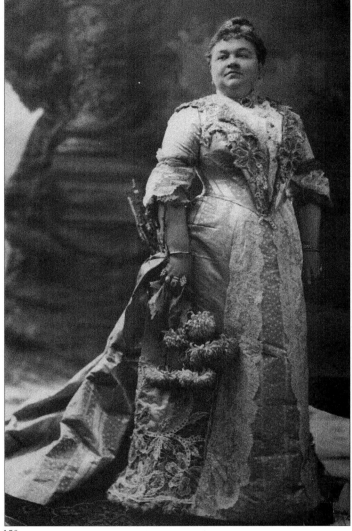

150

148. c.1890. A boy "age 3 yrs 1 month" wearing a dressy velvet outfit. ("*E. A. Ford, Opposite Post Office, Grundy Center, Iowa.*" *Cabinet card.*)

149. c.1890. "Ella K. Ewing, 8 ft 4 in, age 28, weight 256," is well dressed in the popular white dress of the decade, with frills at the shoulders and wrists. The couple with her, presumably her parents, wear typical everyday attire for people of their age. ("*C. M. Husted, Ashland, Neb.*" *Cabinet card.*)

150. c.1890–91. This statuesque woman is dressed in a lavish costume of striped and dotted fabric, ribbon, and laces. She wears ample jewelry, including a photograph pin of a man at her neck. (*Cabinet card.*)

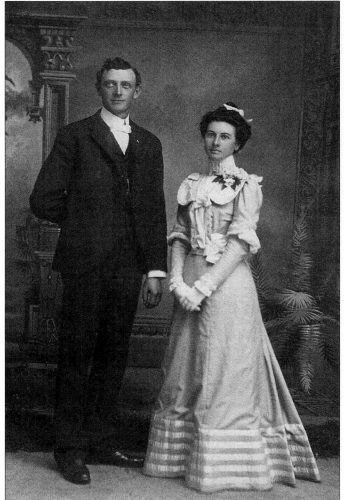

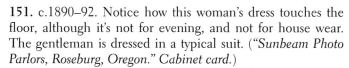

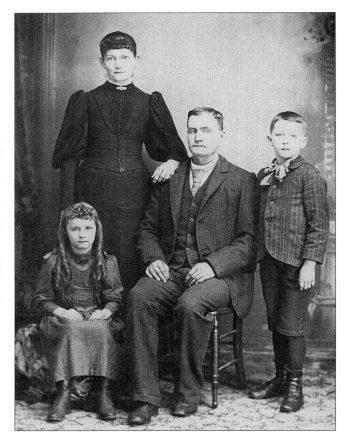

152

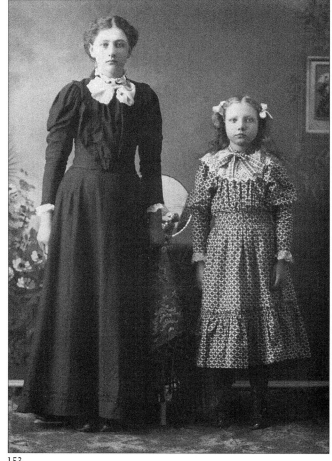

151. c.1890–92. Notice how this woman's dress touches the floor, although it's not for evening, and not for house wear. The gentleman is dressed in a typical suit. (*"Sunbeam Photo Parlors, Roseburg, Oregon." Cabinet card.*)

152. c.1890–92. An American family. The mother wears a simple dress (with no corset), but the lines conform to contemporary fashion. The children wear typical clothing, as does the father. (*"T. W. Dyall, College Art Gallery, Mount Pleasant, Iowa." Cabinet card.*)

153. c.1890–92. These girls wear modestly fashionable dresses. (*Cabinet card.*)

153

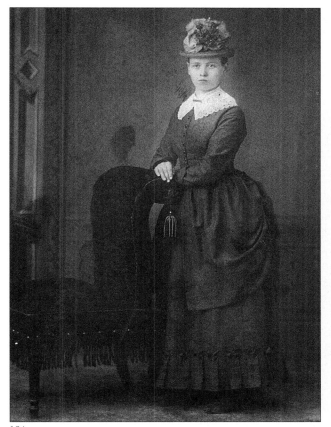

154

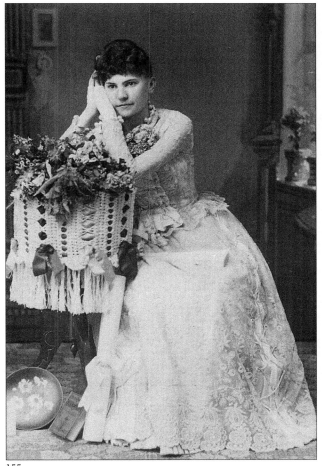

155

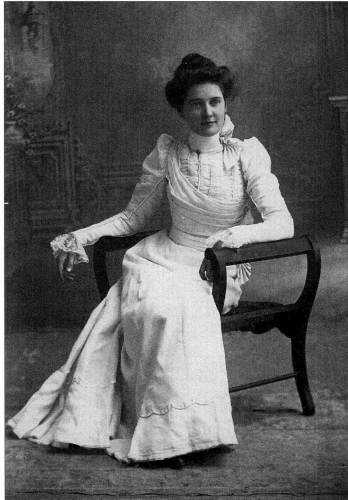

156

154. c.1892. Though this woman's costume is very simple for its era, and was probably either homemade or made by a local seamstress, it does follow the latest lines of fashion, as does her hat. (*"Couat's Riverside Gallery, Manistee, Mich." Cabinet card.*)

155. c.1890–93. This young woman wears the highly fashionable white lace dress in its early years. (*"G. A. Webster, Pecatonica, Ill." Cabinet card.*)

156. c.1890–93. A woman beautifully dressed in a highly stylish white dress. (*Cabinet card.*)

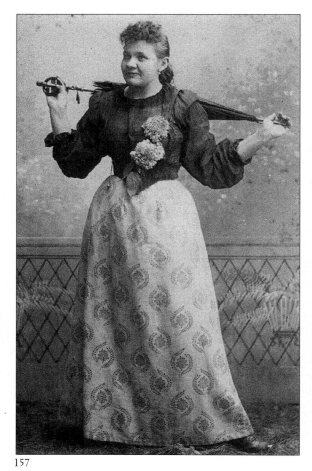

157

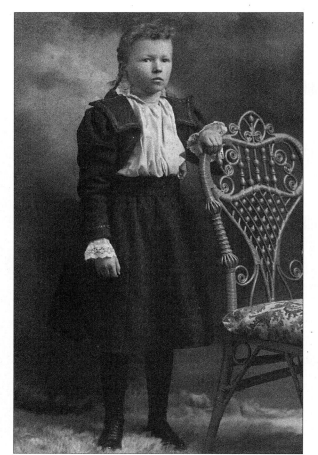

158

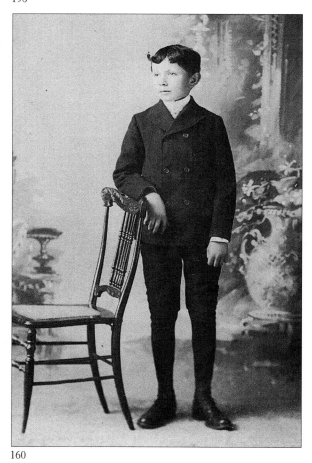

159

160

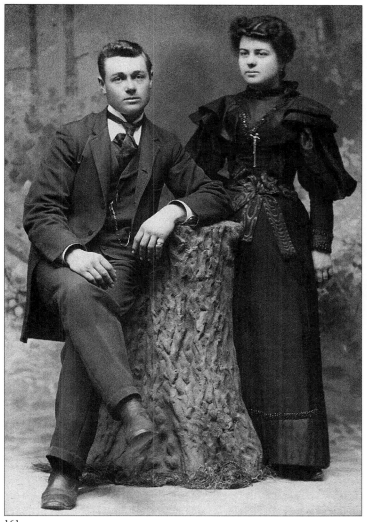

161

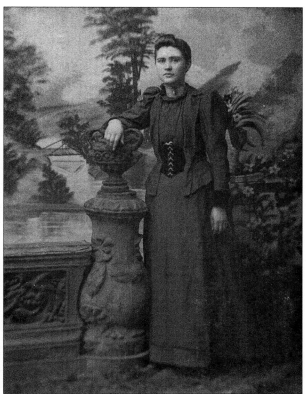

162

162. c.1892. "Esther Garden" in a badly made outfit. It was probably made at home or by a seamstress. (*Cabinet Card.*)

163. c.1892–94. The two women wear dresses cut along fashionable lines but which are either home- or seamstress-made. Note the stripe in the gentleman's trousers. (*"H. D. Graves, Opp. I.O.O.F. Temple, Roseburg, Oregon." Cabinet card.*)

157. c.1890–94. The rounded neckline of this woman's bodice and her sleeves, which are full from shoulder to wrist, are not fashionable, but the basic cut of her skirt and the pointed waistline indicate the early 1890s. (*"Artistic Photography. Vignos & Hurford, No. 219 West Tuscarawas Street, Canton, Ohio." Cabinet card.*)

158. c.1891–92. "Mildred Johnson," fashionably dressed in high button boots and a lace-trimmed dress. (*Cabinet card.*)

159. c.1890–96. A well-dressed boy wearing short pants. (*"Winter, Photo Company. Eugene, Oregon." Cabinet card.*)

160. c.1891–96. This boy wears a suit very much like what his father would have worn, except for the short pants. (*"Cronise Photo, Salem, Ore." Cabinet card.*)

161. c.1891–93. "Aunt Harriet and Uncle Willie Gladwill." The man wears an everyday suit with boots and a wide tie, while the woman wears the new-style sleeve and rounded waistline in a dress that also would be considered "everyday." (*W. M. Willis, Artist, Hale, Missouri." Cabinet card.*)

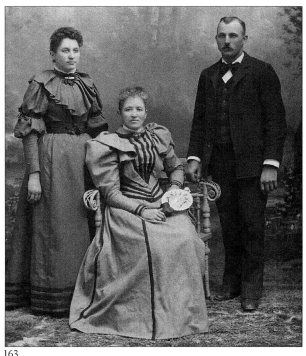

163

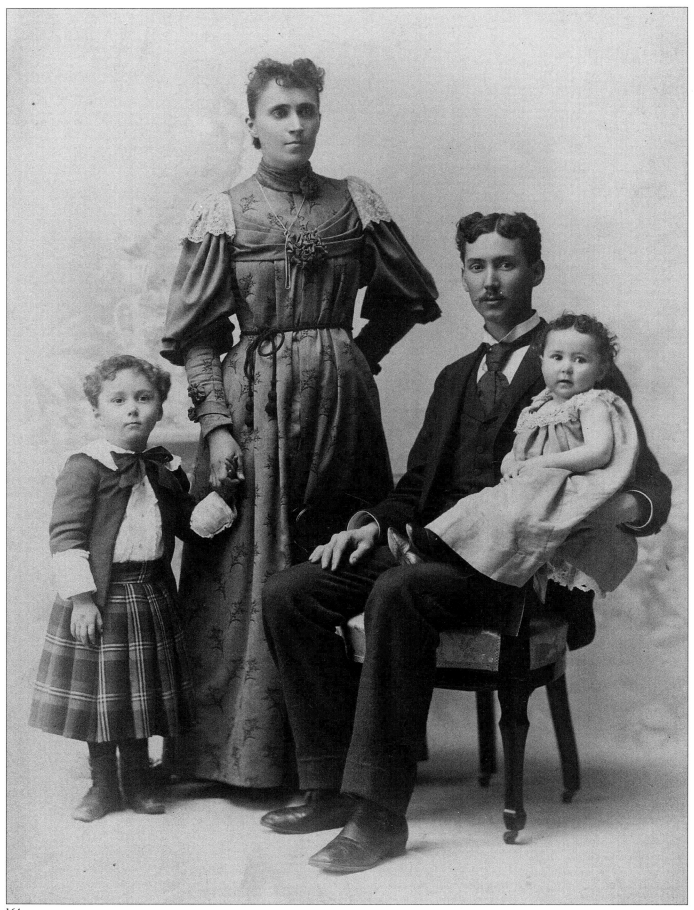

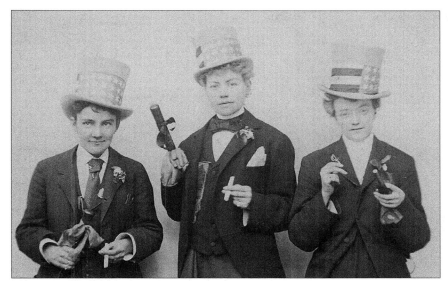

165

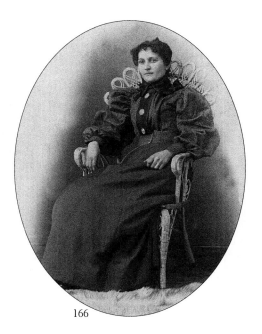

166

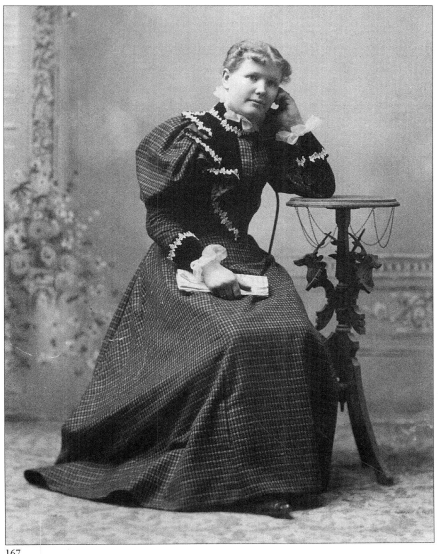

167

164. c.1892–93. "Mr. & Mrs. J. T. Crane & family.—Clare & Elsie." Mrs. Crane wears a rarely photographed (or discussed) maternity dress and holds the hand of her son, dressed traditionally in a skirt. Mr. Crane wears a typical suit and tie. (*"Webster, Paris Panel, 1069 Broadway, Oakland, Cal." Cabinet card.*)

165. c.1894. A rare photograph of three women in male garb: suits, top hats, cigars, and all. A note on the back identifies them as the "Stanford Triplets" from Eureka, California in 1894. They do not appear to have been a stage act. (*"Wunderlich Bros., 335 F Street, Eureka, Cal." Cabinet card.*)

166. c.1893–94. This woman wears a simple day dress with full sleeves (not yet balloon-shaped). (*"J. E. Kester, Brockwayville, Pa." Cabinet card.*)

167. c.1893–95. The sleeves on this woman's dress indicated the spread of the "leg-o'-mutton" style. Notice the asymmetrical bodice. (*"Holand, South 3rd St., Grand Forks N.D." Cabinet card.*)

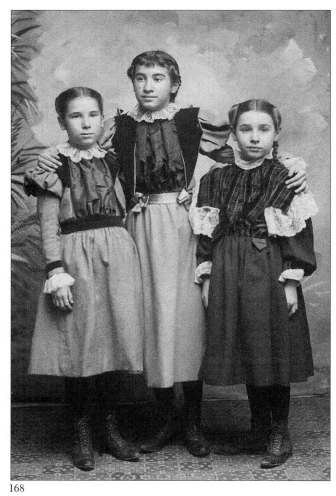

168

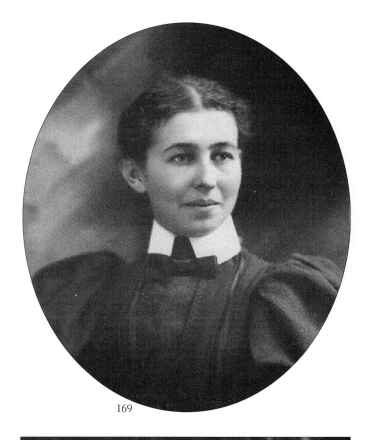

169

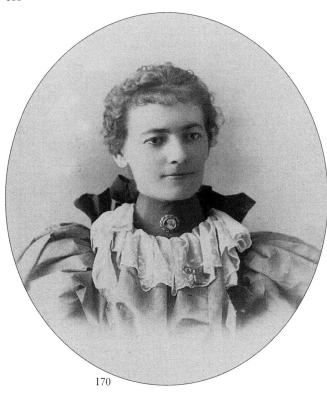

170

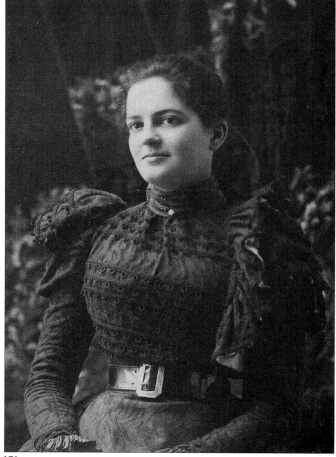

171

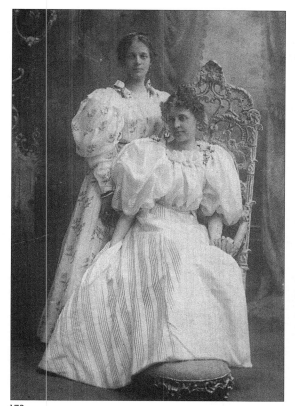

172

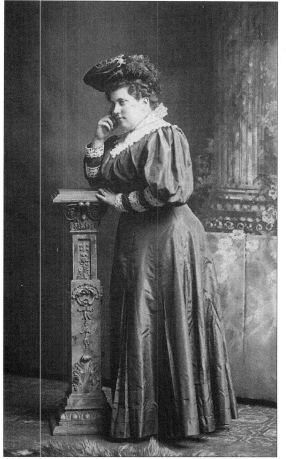

173

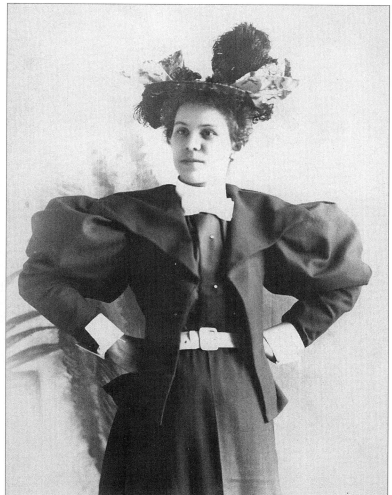

174

168. c.1894–97. Three well-dressed girls wearing lace-up boots, the new fuller bodice, lace frills, and puffed sleeves. (*"F.W. Sander, Monee, Ill." Cabinet card.*)

169. c.1895. A New Woman wearing the huge balloon sleeves of the era, and a bodice of tailored, masculine-inspired design. (*"McLane, Homestead, Pa." Cabinet card.*)

170. c.1895. This young woman sports the latest, high, wide collar and equally wide sleeves. Notice the photo pin on her neck. (*"Mesarvey, Finest Finish, 165½ Third St., Portland, Or." Cabinet card.*)

171. c.1895. A young lady in an elaborately braid-trimmed bodice. (*"Whigham, 22 Kearny St., San Francisco, Cal." Cabinet card.*)

172. c.1895. "Teresia L. Myer and Mabell Chloe Hyde, August 20, 1895, 20th birthday." Both ladies wear highly fashionable, light and frothy dresses. (*"Pryor, La Crosse, Wis." Cabinet card.*)

173. c.1895–97. This woman is dressed in typical middle-class attire. (*"H. T. Biel, 417½ Wabash Ave., Terre Haute, Ind." Cabinet card.*)

174. c.1895–96. "Cad Chester," a jauntily dressed New Woman wearing a masculine-inspired suit, complete with studs, wide cuffs and collar, and bow tie. (*"J. W. Unser, Artistic Photographer. Tiffin, Ohio." Cabinet card.*)

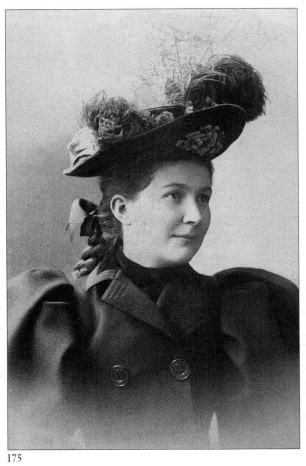

175

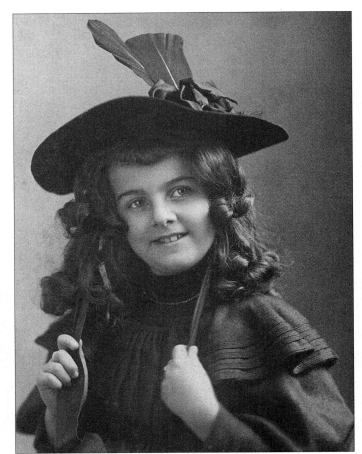

176

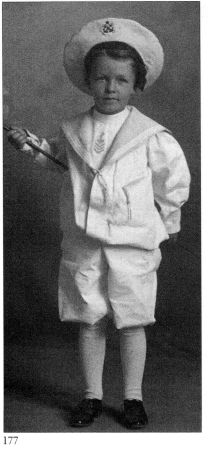

177

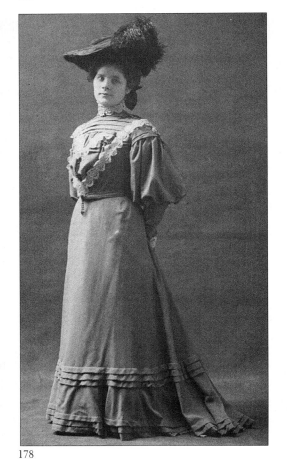

178

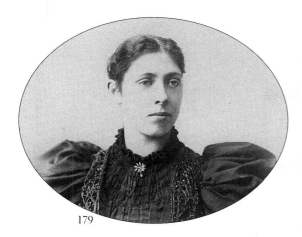

179

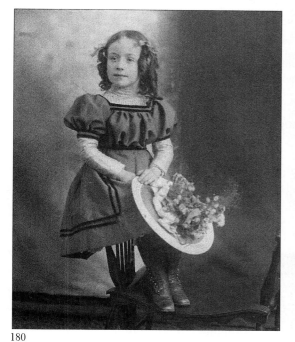

180

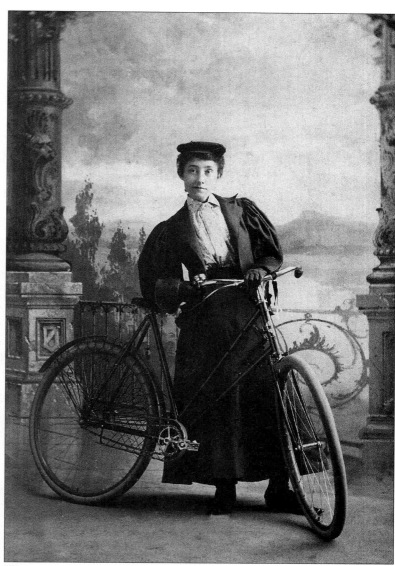

181

175. c.1896. "Mary McHugh," wearing the massive sleeves of the mid-1890s, along with a lavish hat trimmed even on the inner brim. A note on the back of the photo sets her age at 17, which is probably correct, since she wears her hair in a bow-trimmed braid. (*"Jewell's Studio, Scranton, PA, 303 & 305 Spruce St." Cabinet card.*)

176. c.1895–98. This little girl wears the latest in fashion. (*"De Vos and Hogue, South Bend, Ind." Cabinet card.*)

177. c.1895–1902. A well-dressed little boy in his white (and therefore "fancy") sailor outfit. (*"Bell, Girard, Kansas." Cabinet card.*)

178. c.1897. This lady's basic lines are correct, but her dress is less than fashionable because of its poor fit and poor-quality details. Her hat is very typical. (*"Milwaukee Art Studio, 268 West Water St., Milwaukee." Cabinet card.*)

179. c.1895–97. A woman wearing a highly fashionable, jet trimmed, and smocked bodice. (*"Hartsook, Marion, Ind." Cabinet card.*)

180. c.1897. With her round, well-trimmed hat, high neckline, double sleeves, and velvet ribbon trim, this girl is very well dressed. (*Cabinet card.*)

181. c.1896. "Mollie Gastrell, Oct. 1896," wearing a modest bicycling outfit: a long skirt (probably with bloomers beneath), low-heeled shoes, gloves, and jaunty hat. (*"O. E. Aultman, Photographic Art Studio, 319 W. Main St., Trinidad, Colo." Cabinet card.*)

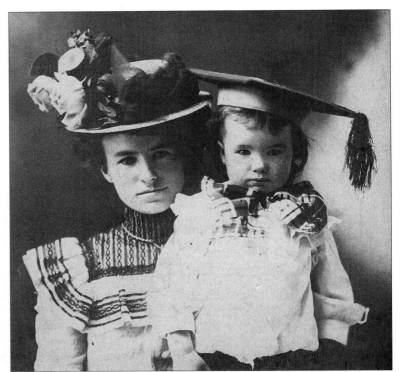

183

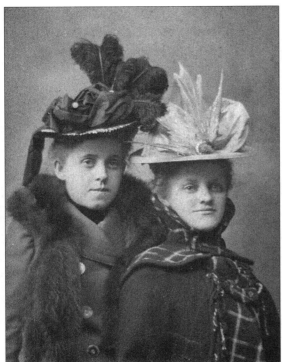

182

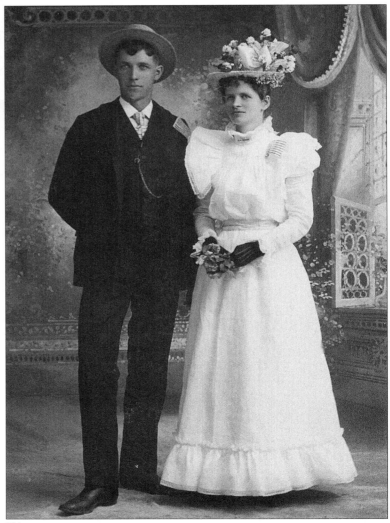

182. c.1898. These ladies wear the latest in millinery: plumes waving high and whole birds mounted proudly onto hats. They also wear jackets: one smartly trimmed with a high plaid collar, cape, and scarf, the other trimmed with fur. (*"Yager, 119 Main St., Galesburg, Ill." Cabinet card.*)

183. c.1897–99. This mother is dressed fashionably, and her son wears an unusual hat that appears to be for more than just fun, since it fits him perfectly. (*Cabinet card.*)

184. c.1897–1900. Stylishly dressed in everyday attire, this man and woman wear miniature American flags on their shoulders. (*"Cheney, Oregon City, Oregon." Cabinet card.*)

184

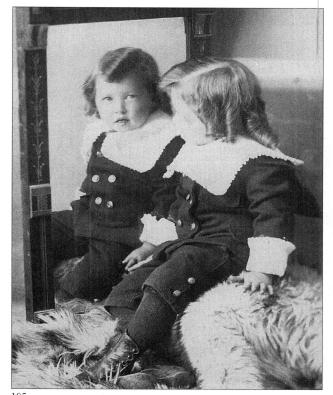

185

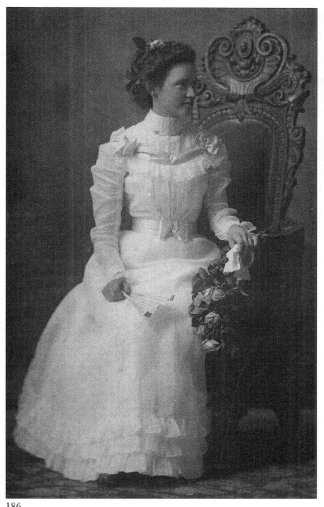

186

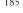
187

185. c.1898. "Fred Maher, May 9, 1898," wearing a very typical suit, inspired by the tale of Little Lord Fauntleroy. ("*A. D. Fox and Son, Pomeroy and Asotin, Wash.*" *Cabinet card.*)

186. c.1898. "Myrtle Taylor, Garden City, Minn. When she graduated from Mankato Normal School about 1898." White dresses were *the* thing to wear for graduation, but served many other purposes afterward. ("*Snow, Mankato, Minn.*" *Cabinet card.*)

187. c.1898. "Gussie, May 13th, 1898." Note her wide sleeves and stylish hat. ("*A. B. McAlpin, 129 Seventh St., Portland, Or.*" *Cabinet card.*)

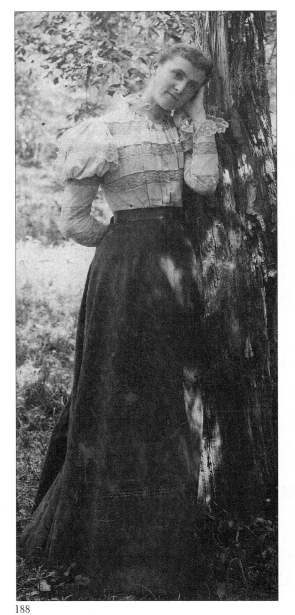

188

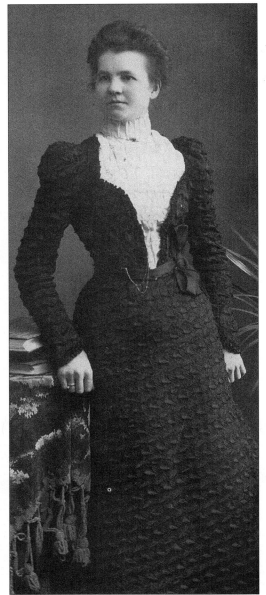

189

188. c.1898–99. "Fran Chatfield, Har[.], Conn," dressed in everyday attire of a dark skirt and a white bodice. (*Cabinet card.*)

189. c.1898–99. "Miss Maggie Parker" in a dress made stunning by its textured fabric. The slightly shaped waistline and high collar are typical of the turn of the century. (*"Snodgrass, Astoria, Ore." Cabinet card.*)

190. c.1899–1900. A young lady showing off her fashionable "New Woman" jacket, a photo pin on her neck, and a watch. (*Cabinet card.*)

191. c.1899. Women in typical evening dresses. (*"An Affair of Honor—the Successful Thrust." Stereo card.*)

192. c.1899. This man wears a rather well-worn suit (notice how his vest gaps in the middle); the woman on the left wears a heavy velvet dress, and the younger woman on the right wears an up-to-date ensemble trimmed with many ribbons. (*"Clodfelter, Versailles, Mo." Cabinet card.*)

193. c.1899–1900. A simply but very well-dressed woman wearing a tailored suit with a "man-style" collar and bow tie, and a richly plumed hat. (*"Ganiere & Layton, 3140 State St., Chicago." Cabinet card.*)

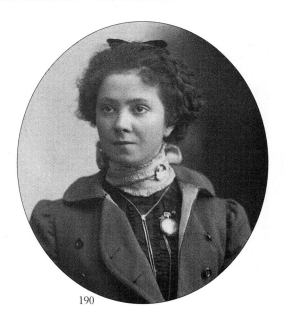

190

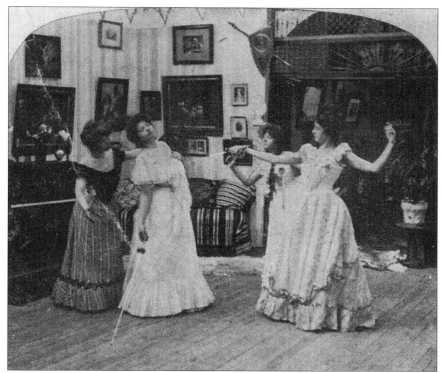

191

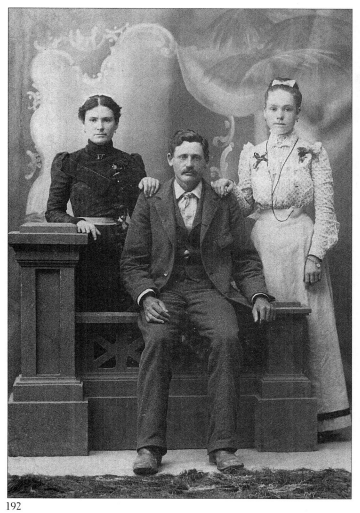

192

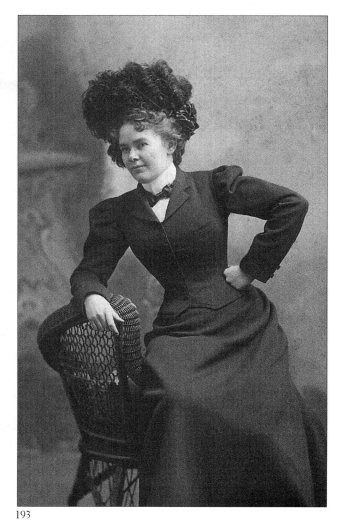

193

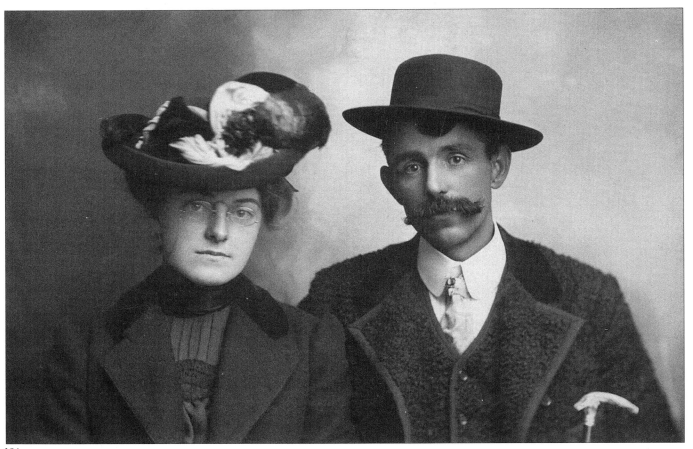

194

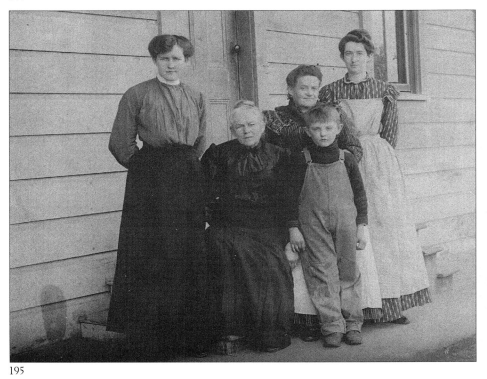

195

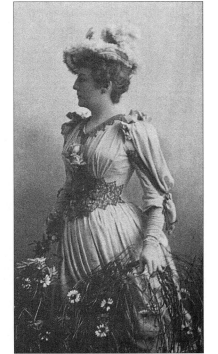

196

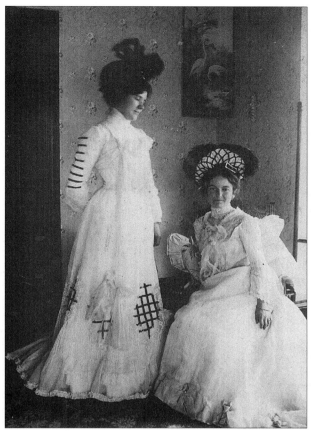

197

199

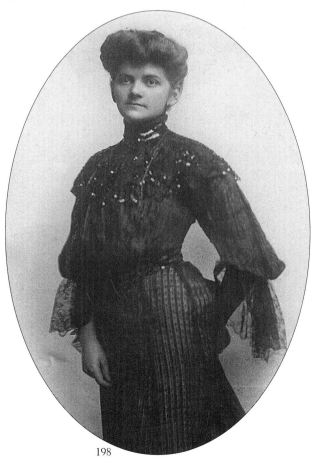

198

194. c.1899. "Aunt Alice [and] Dad Taliaferro." He wears a lambs-wool suit and carries a cane. She has on a well-tailored jacket and the latest in millinery. (*"The Elite, Salem, Ore." Cabinet card.*)

195. c.1899–1900. Typical working clothes of American farmers. The boy wears denim overalls, left unhemmed for his growth spurts, and the women wear washable, practical clothes. The woman on the far right wears a pin-on apron. (*Cabinet card.*)

196. c.1899–1900. An actress wearing a romantic lace- and flower-trimmed dress and hat. (*CDV.*)

197. c.1899–1900. Two trendy women. The dress on the left is unusual for this era because of its dark geometric trimming. (*Gelatin print.*)

198. c.1899–1900. A highly fashionable woman in a dark dress trimmed with wide lace flounces and jet. (*"Klein and Guttenstein, Milwaukee." Cabinet card.*)

199. c.1899–1903. A young woman dressed in an exquisite lace bodice. (*"Kurimoto, 1930 Fillmore St., S.F." Cabinet card.*)

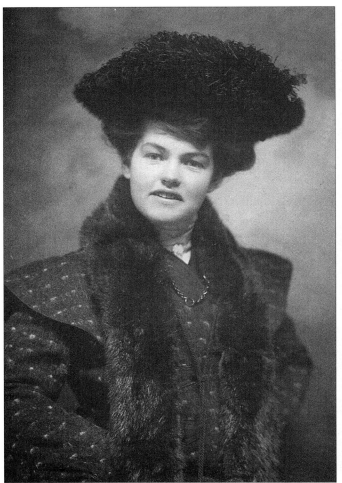

200

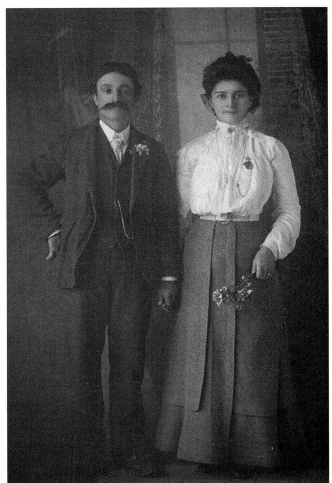

201

200. c.1899–1905. A highly fashionable woman wearing a smart tailored jacket, a fur wrap, and a plumed hat. (*"J. J. Prescott, Melrose, Minn." Cabinet card.*)

201. c.1899–1906. This couple's photo is unusual in that it shows them holding hands. They are both dressed modestly, but fashionably. (*Cabinet card.*)

202. c.late 1890s. Though the average woman would never wear a bicycling suit in such loud plaid fabrics, the style of this woman's bloomers, shirtwaist, shoes, and hat are typical of what was worn by daring women; many more women would have worn a short skirt over the bloomers. (*Stereo card.*)

203. c.late 1890s. These two sisters ("Aunt Beatrice & Aunt Ruth") wear reform clothing. The sister on the left wears a short skirt and clothing that is quite loose for the period. The other wears a more radical garment with a high waist and a very full skirt. (*"J. P. Beyers, Coquille City, Oregon." Cabinet card.*)

204. c.late 1890s–early 1900s. "Uina and Lena" playing dress-up. (*Gelatin print.*)

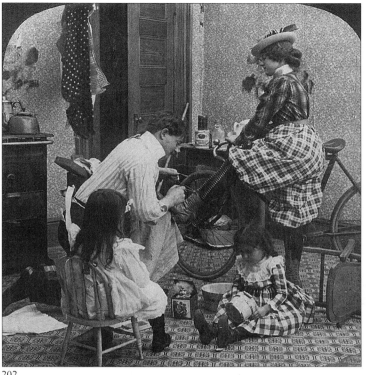

202

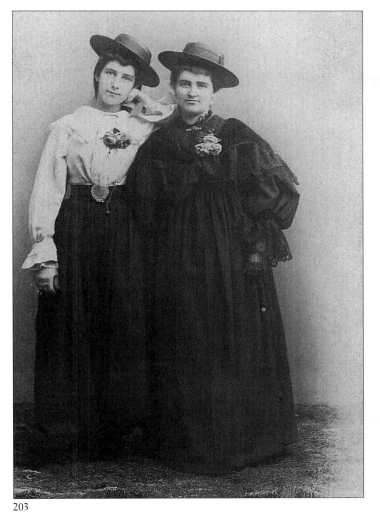

203

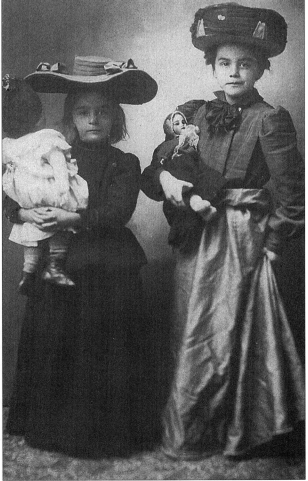

204

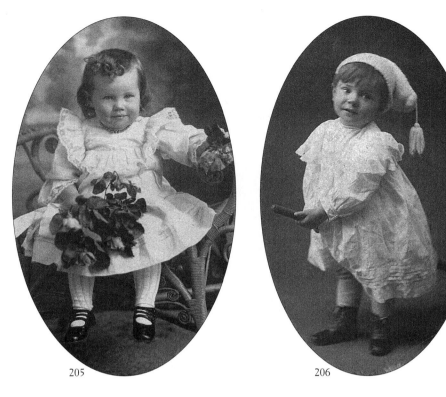

205

206

205. c.late 1890s–early 1900s. "Rominia Eastman" in typical toddler's attire. (*Cabinet card.*)

206. c.late 1890s–early 1900s. A boy dressed in what was, at this time, a typical baby's white dress, buttoned boots, and a knitted cap. (*Cabinet card.*)

207. c.late 1890s–early 1900s. The standing woman wears a lavish tea gown, while the woman on the floor wears a typical dress. ("*How very great the very small are.*" *Stereo card.*)

208. c.late 1890s–early 1900s. Two children dressed in typical special-occasion baby attire. ("*J. Smith, Photographic Artist, Lansdown Studio and 7 George St., Stroud.*" *Cabinet card.*)

209. c.1900. This woman wears a lace bodice with a photo pin at her neck, and a fashionable hat. ("*C.H. Bradsaw, Newport, Oregon.*" *Cabinet card.*)

210. c.1900. This young girl with her concert zither is dressed very well in jewelry and a simple but rich dress. ("*Wheeler, Goshen, N.Y.*" *Cabinet card.*)

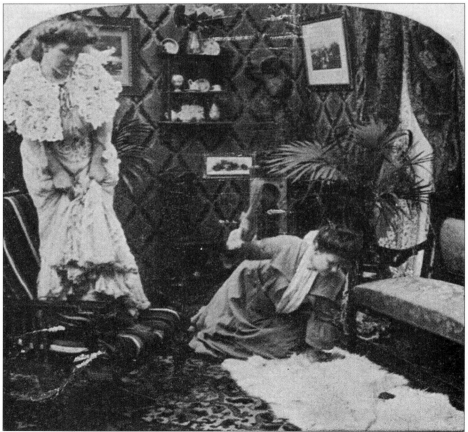

207

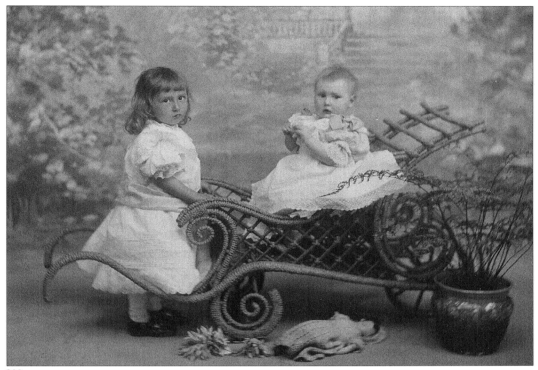

208

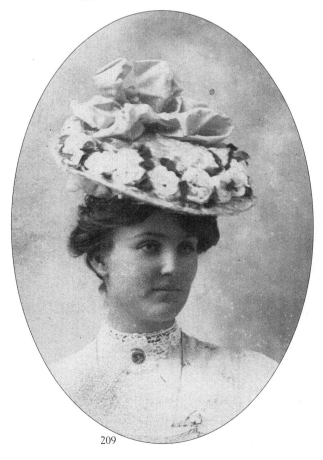

209

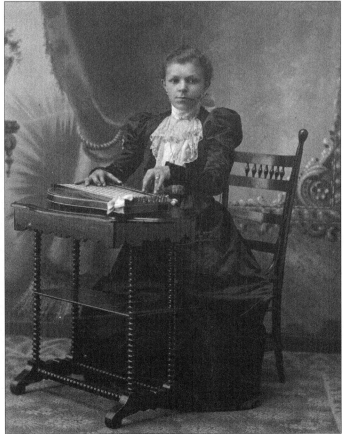

210

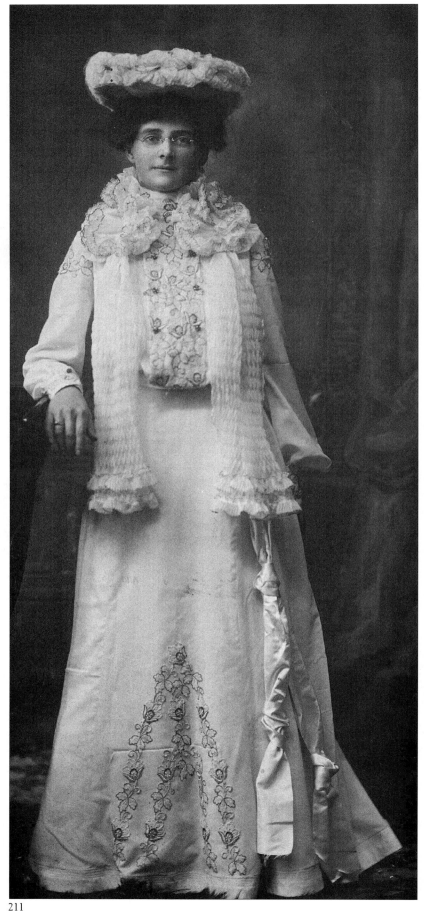

211

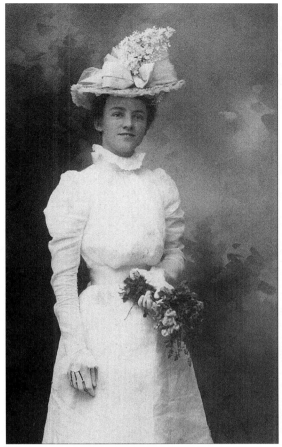

212

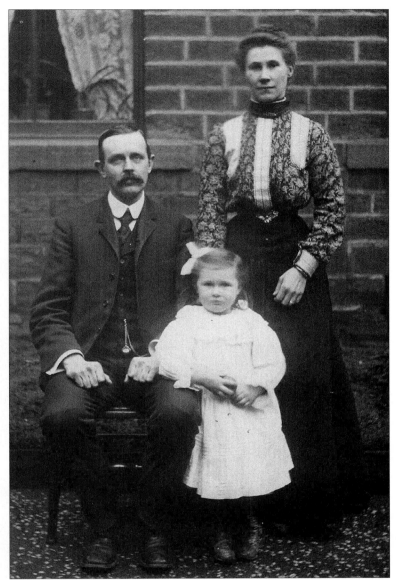

214

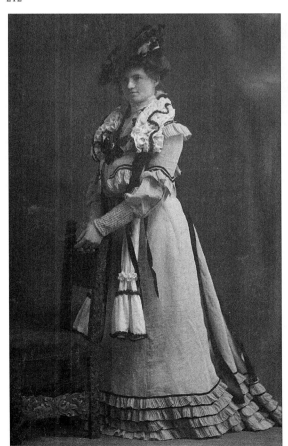

213

211. c.1900. A very fashionable woman wearing an embroidered dress, a ruched chiffon boa, and a hat trimmed with silk flowers. (*Cabinet card.*)

212. c.1900. A young woman dressed relatively simply, but also stylishly, in her white dress, perfectly adorned hat, and embroidered gloves. (*"Miss B. Wrensted, Pocatello, Idaho." Cabinet card.*)

213. c.1900. "Aunt Minnie" dressed in a fashionable gown and ruched boa. (*Cabinet card.*)

214. c.1900–01. This photo is unusual in that it appears to have been taken outdoors, but is still posed like a studio portrait. The woman's waist is well corseted, and she wears a simple but fashionable outfit. The man wears a typical suit with his watch on a fob, and the child wears the white dress "uniform" of the period. (*"George Baxter, 16, Saltaire Road, Shipley." Cabinet card.*)

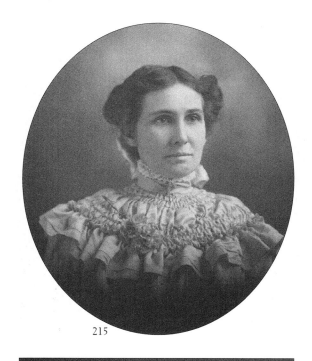

215

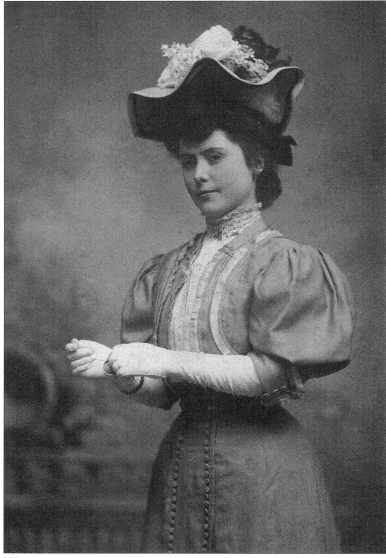

217

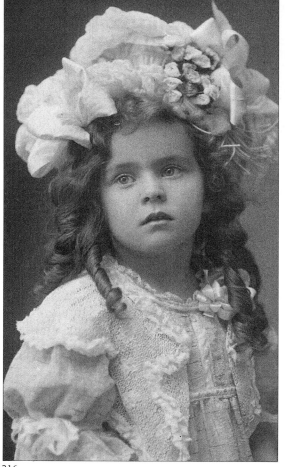

216

215. c.1900–01. "Florence W. Andersen" with an extravagantly trimmed bodice. (*Cabinet card.*)

216. c.1900–01. A wealthy young girl dressed elaborately in a white lace dress and fancy hat. (*Cabinet card.*)

217. c.1900–01. A smartly dressed woman in the latest dress and hat style. ("*Davies, Third & Morrison St., Portland, Ore.*" *Cabinet card.*)

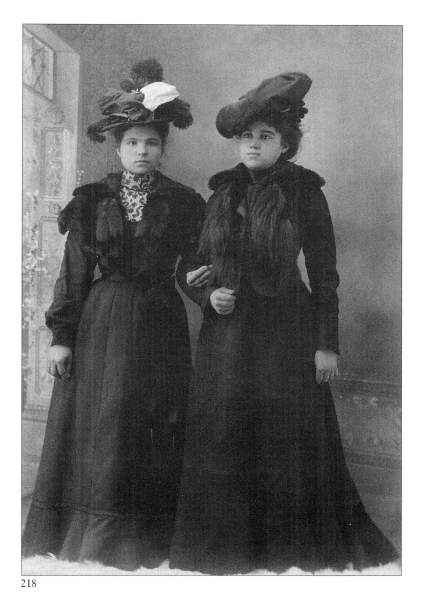

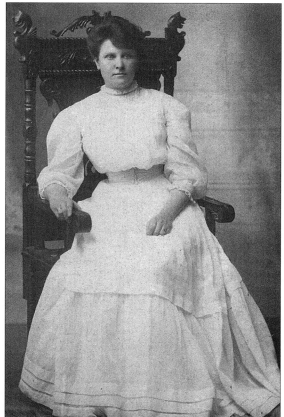

219

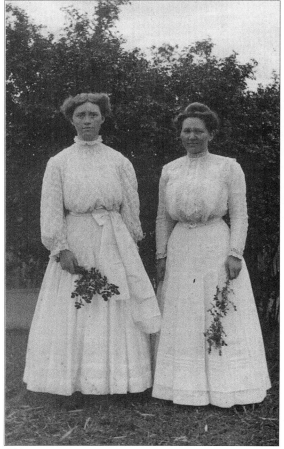

220

218. c.1900–03. These two women have many of the trappings of fashion (including hats in fashionable shapes, and furs), but they haven't quite pulled them together. Their dresses are on the coarse side, and their hats more simply trimmed than was preferred at this time. (*"G. F. Porter, Ritzville, Washington." Cabinet card.*)

219. c.1900–02. A lady wearing the typical white dress of the era, with a wide belt. (*Gelatin print.*)

220. c.1900–04. Middle-class American women in typical white attire. On the back is written: "Dear Friend, Here is a proof of yours and Mayse's picture. If it is satisfactory let me know at once if you wish them and how many. . . . Your friend, Clyde" (*Postcard.*)

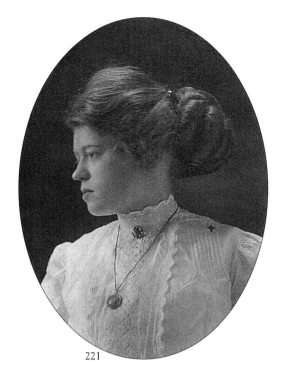

221

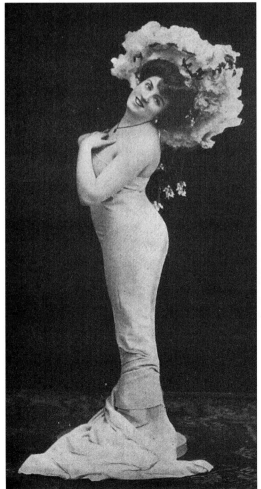

222

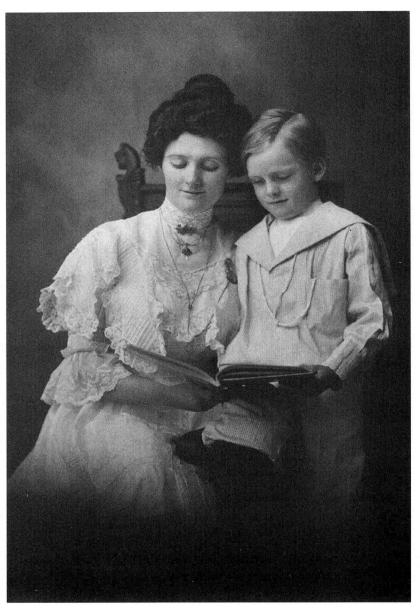

223

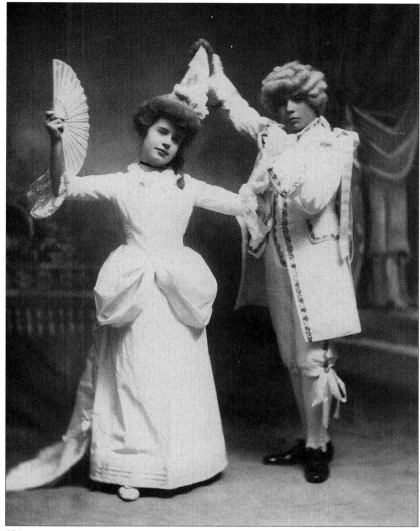

224

225

221. c.1900–05. "Cousin Hazel Rossiter" in a white shirtwaist. (*"Rowena M. Hogan, 525 Abington Bldg., Portland, Ore." Cabinet card.*)

222. c.1900–05. This beauty wears a huge flowered hat that would probably never have been worn anywhere except in front of the camera or onstage. She's wrapped in a glorified sheet, but the silhouette is very close to what the most fashionable evening gowns of the period achieved. (*Postcard.*)

223. c.1900–05. This mother wears a very fashionable white lingerie dress, while her son wears a typical romper suit that was never designed for romping. (*"Witzel Palace Studio, 1426 Fourth Ave. Cor. Pike, Seattle, Wash." Cabinet card.*)

224 & 225. c.1900–05. Children in fancy dress costumes depicting eighteenth-century dress. The girl's costume is merely a simple dress from her own era, with train and hip panniers added. The boy's costume is more accurate and is lavishly trimmed with lace and ribbon. (*Cabinet card.*)

226

227

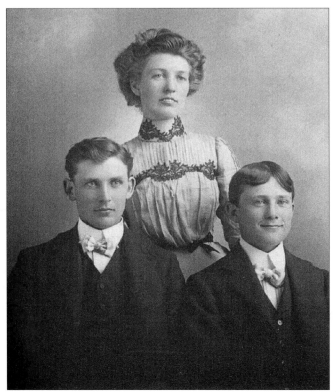

228

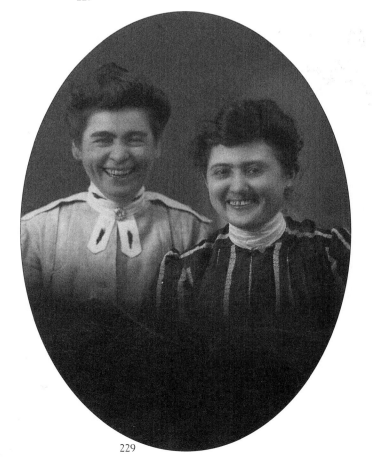

229

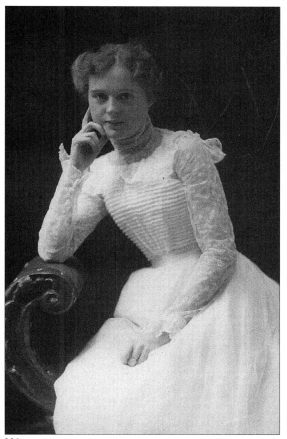

230

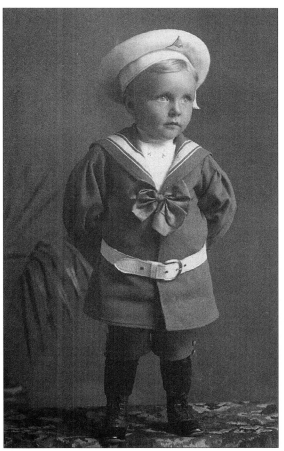

231

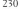

232

226. c.1900–05. A woman wearing a tailored coat and skirt, with a paisley-printed bodice trimmed with pintucks and lace. (*Postcard.*)

227. c.1901–03. Large, wide hats were coming into vogue in the early 1900s, and frequently featured massive plumes as their main focus. Notice the woman's feather boa, as well. (*Miniature cabinet card.*)

228. c.1900–08. The young men wear special-occasion suits, and the woman a pigeon-fronted bodice trimmed with black lace. (*Cabinet card.*)

229. c.1900–06. An unusual photograph in that it captures people smiling. The women wear trimmed shirtwaists with separate collars. (*"Linworth, Ft. Smith, Ark." Cabinet card.*)

230. c.1900–09. This young lady is dressed in the popular white dress of her era, trimmed with tucks and lace. (*"Pach Bros., 935 B'dway, N.Y." Cabinet card.*)

231. c.1901–05. A boy dressed in high fashion in a little sailor suit and hat. (*"Snodgrass, the Fotografer. Successor to Cheney. Oregon City, Oregon." Cabinet card.*)

232. c.1901–04. A classic white lace dress with a pigeon-front bodice. (*"Butterworth, Portland, Ore." Gelatin print.*)

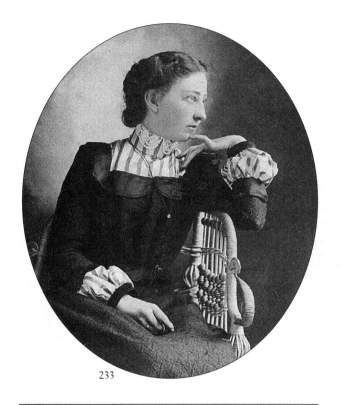

233

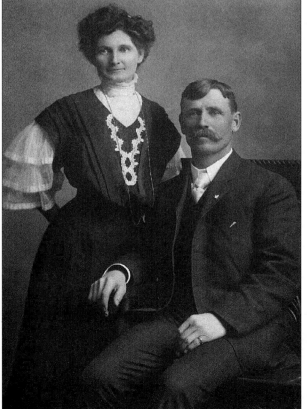

234

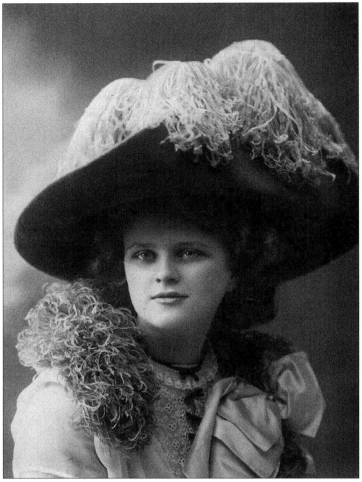

235

233. c.1903. A young woman dressed in a high-fashion bodice. (*"C. H. Collins, 420 Wabasha St., St. Paul, Minn." Cabinet card.*)

234. c.1901–05. A man in a fine day suit, and a woman wearing a fashionable yet relatively simple dress with flowing sleeves. (*"Decen, Grand Junction, Colo." Cabinet card.*)

235. c.1901–06. A very fashionable lady in a wide plumed hat, a feather boa, and a lace- and ribbon-trimmed bodice. (*Postcard.*)

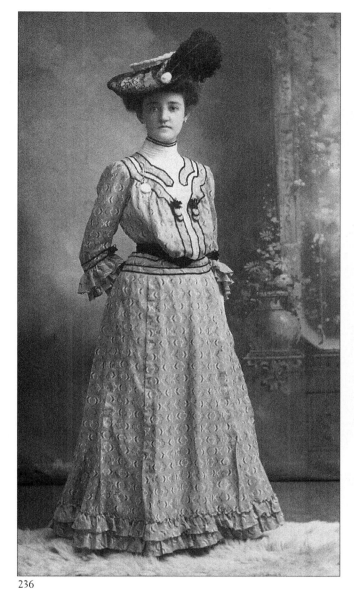

236

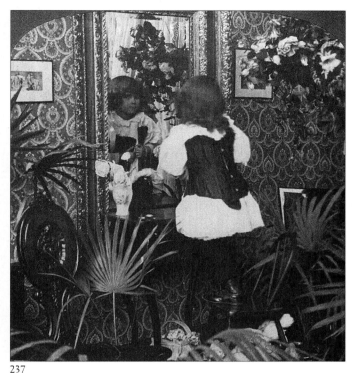

237

236. c.1903–04. "My Sister" in a fashionable pigeon-front bodice, yoked skirt, and feathered hat. ("*G. F. Martin, 828 Shelby St., Lou. Ky.*" Cabinet card.)

237. c.1903. A little girl trying on Mommy's corset—backwards. ("*'Like mamma does.' International Stereograph Co., Photographers and Publishers, Home Office and Works, Decatur, Illinois, U.S.A.*" Stereo card.)

238. c.1903. The young woman on the right is fashionably dressed in a dark skirt and light blouse. ("*Zahner, Niagara Falls, N.Y.*" Cabinet card.)

238

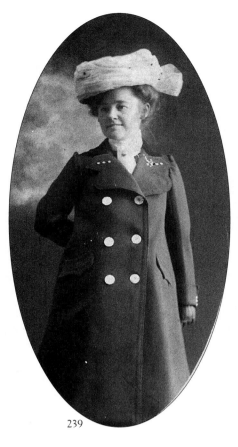

239

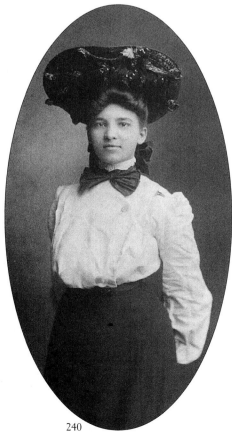

240

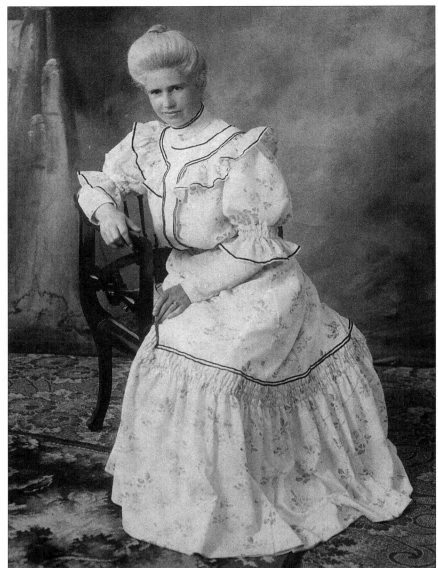

241

239. c.1903–04. This woman wears a simple but fashionably shaped hat and a simply decorated jacket. (*Cabinet card.*)

240. c.1903–04. This teenage girl wears the "uniform" of every "proper" woman of her era, a dark skirt, white shirtwaist, and the latest hat. (*"Eppert & Son, Terre Haute." Cabinet card.*)

241. c.1903–06. A young woman wearing a pretty, frothy white print dress, trimmed with ruffles and smocking. (*Cabinet card.*)

242. c.1903–04. "Bessie" wearing a street costume of sturdy boots, dark, short walking skirt, white blouse, and duster. (*"O. L. Markham Photo." Cabinet card.*)

243. c.1903–07. This young woman wears a white dress trimmed with pintucks and a wide ribbon belt. (*Postcard.*)

244. c.1903–07. Perfectly dressed in the "lingerie" style, this woman dons a cotton eyelet dress and a hat boasting grapes. (*Gelatin print.*)

245. c.1903–08. This group is dressed in everyday attire. Notice the bow ties on the men, and the typical white lace-trimmed dresses on the women. (*"Albert Studio, Board Walk, Atlantic City, N.J. Opposite Young's New Million Dollar Pier." Postcard.*)

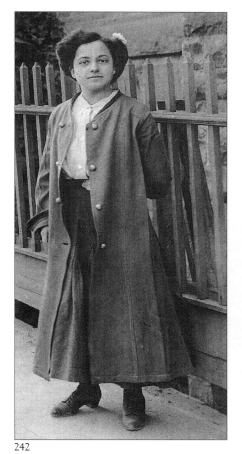

242

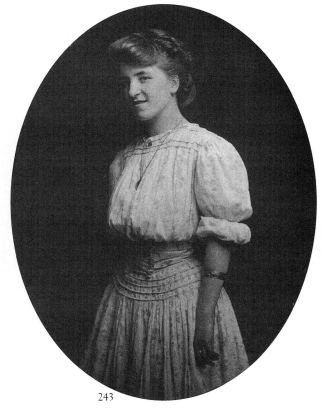

243

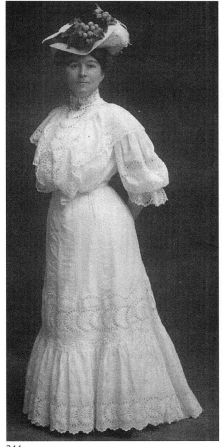

244

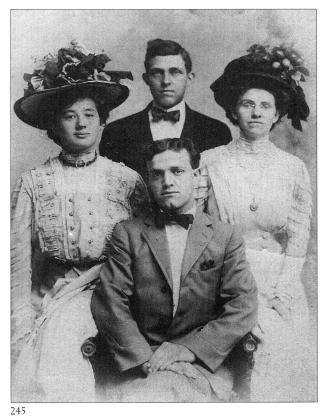

245

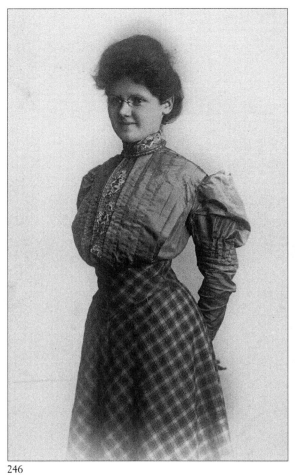

246

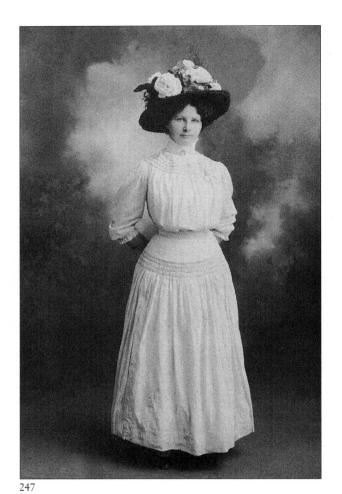

247

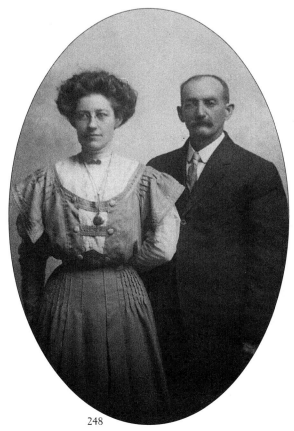

248

249

250

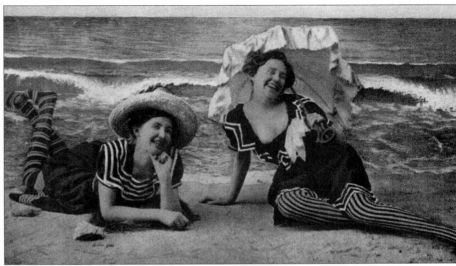

251

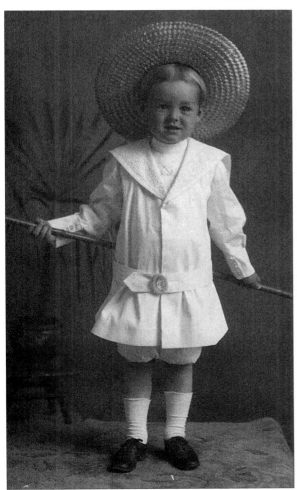

252

246. c.1903–09. "Miss Sarah Baker" in a fashionable skirt with a matching wide belt, and a delicately trimmed bodice. ("*Graham Studio, Beloit, Kans.*" *Cabinet card.*)

247. c.1905. This woman is dressed in an everyday dress and hat. (*Postcard.*)

248. c.1905. A man and woman in typical middle-class dress. ("*Poe, Oconomowoc, Wis.*" *Cabinet card.*)

249. c.1907. A commercially made photograph, poking fun at the enormously popular, and enormously large, Merry Widow hat. (*Postcard.*)

250. c.1905–08. Women occasionally posed in their bathing suits at boardwalks (or in a photographer's studio, as this woman appears to have done). Atypically, however, she poses rather brazenly in translucent stockings (instead of thick black ones) and shoes (instead of more concealing boots), and not only without headgear, but with her hair falling below her waist. (*Tintype.*)

251. c.1905–10. Two young women dressed in unusually revealing bathing costumes. (*Postcard.*)

252. c.1905–07. This boy is dressed in a highly fashionable white suit and wide-brimmed Buster Brown-inspired straw hat. ("*Snodgrass, the Fotografer. Successor to Cheney. Oregon City, Oregon.*" *Cabinet card.*)

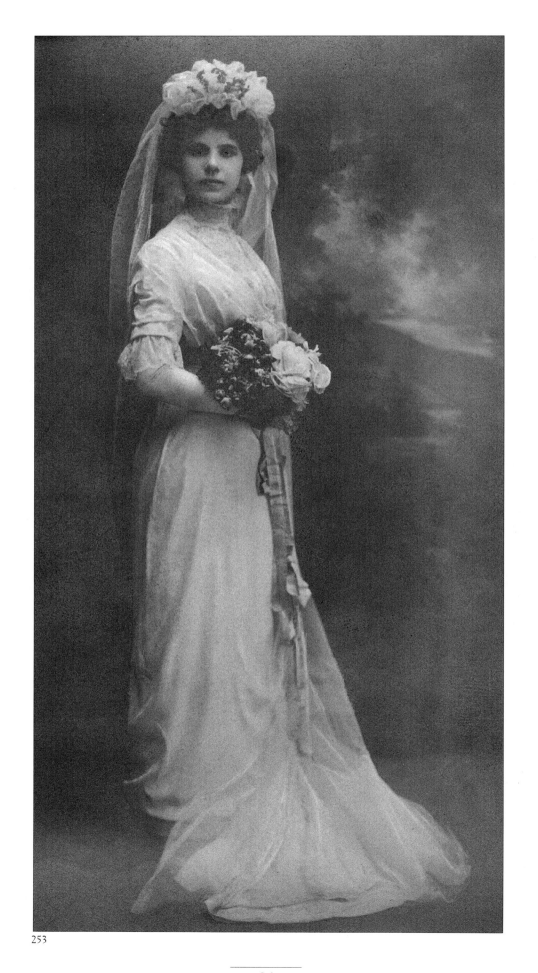

253

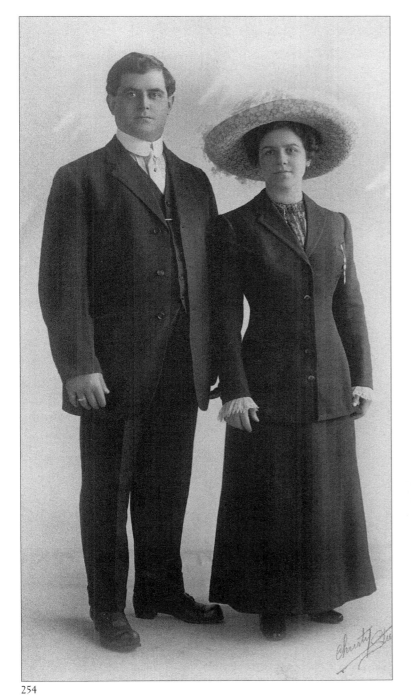

254

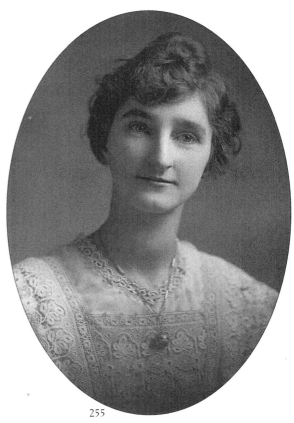

255

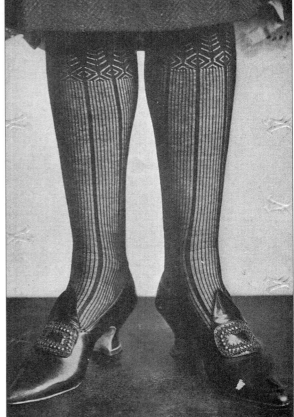

256

253. c.1907–09. A bride in the new more sleek and slim style. (*"Kaufman Studio, 2858 Third Ave., Near 149th St., New York."* Cabinet card.)

254. c.1908. This woman is dressed very much like her male companion, except for her skirt and wide-brimmed hat. (*"Christy Studio, Seattle." Gelatin print.*)

255. c.1909–10. A woman wearing a lace bodice. (*Gelatin print.*)

256. c.1910s. Typical women's stockings and shoes. (*Postcard.*)

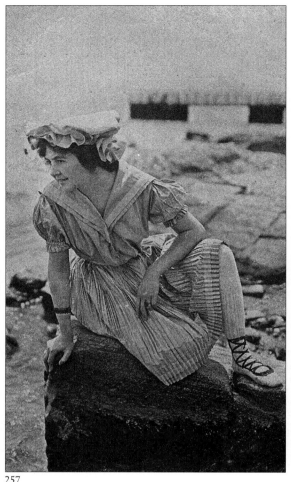

257

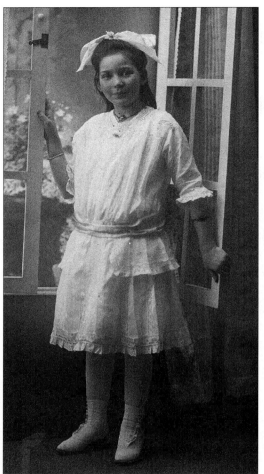

258

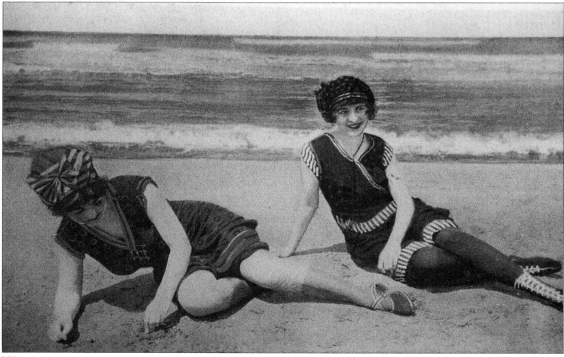

259

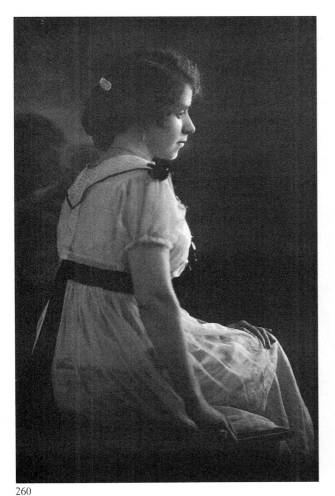

260

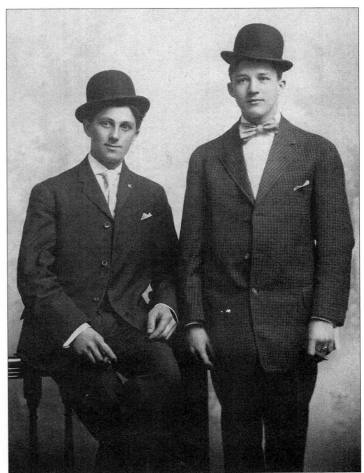

261

257. c.early 1910s. A woman wearing a generously full bathing dress and hat, along with thick stockings and bathing slippers. (Postcard.)

258. c.1910s. "My First Communion." This young girl is dressed in typical special-occasion attire: white dress with sash, wide bow in hair, and white high button boots. (*Cabinet card.*)

259. c.1910s. Two young women in the latest bathing attire. (*Postcard*)

260. c.1910s. This lady is dressed typically in a double skirted dress with a high waist and short sleeves. ("*Rohuer, Carroll, Iowa.*" *Cabinet card.*)

261. c.1910s. "Fredie Hewler and Pal" dressed in dapper suits and cocked bowler hats. ("*The Pernell Studio, 107 W. State St., Sharon, Pa.*" *Cabinet card.*)

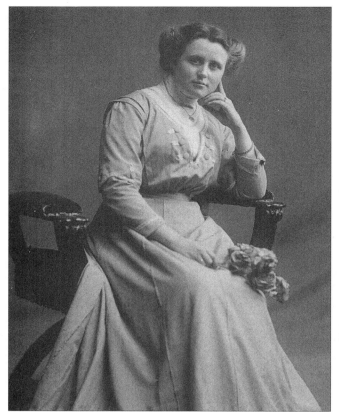

262

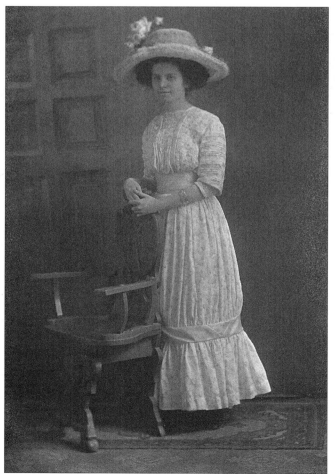

263

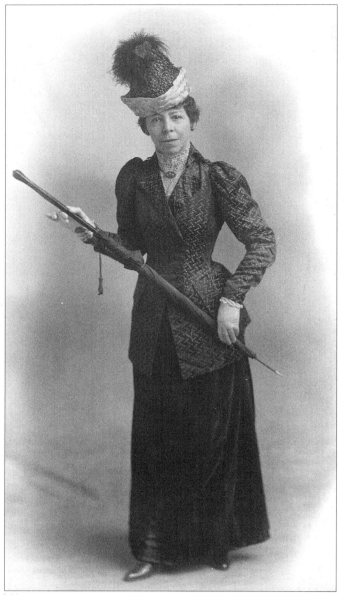

264

262. c.1910. "Rydal M. Rawes" wearing modest but reasonably fashionable clothing. (*"The Diamond Studios, 150 Rundle St., Adelaide." Cabinet card.*)

263. c.1910–12. A sweetly dressed young woman in an era when more sophisticated styles were coming to vogue. Nonetheless, her slimmer skirt, higher waistband, and sash were within usual style lines. Her hat is unusual for the era. (*Gelatin print.*)

264. c.1910–12. An extremely fashionable woman. She is probably a bit ahead of her time in millinery; when waists were still defined as hers is, most hats were broad, not tall. Notice her skin–tight gloves, her perfectly wrapped parasol, and her jewelry. (*Gelatin print.*)